The College History Series

SETON HALL
UNIVERSITY

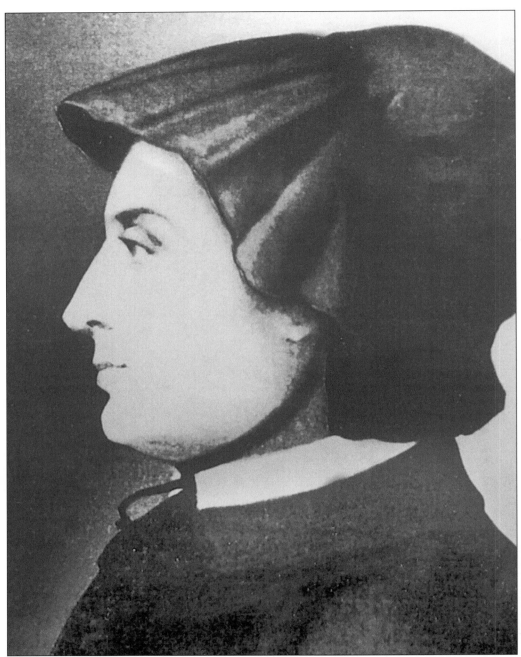

Educator and philanthropist Elizabeth Ann Bayley Seton ("Mother Seton") was canonized in 1975, the first American saint (and the second American citizen) to be canonized after Italian-born Mother Frances Xavier Cabrini in 1946. She married William Seton in 1794, who died in Pisa. Of Mother Seton's children, Catherine became Mother Catherine of the Sisters of Mercy of New York and lived to the age of 90. Her sons went to Georgetown College. In 1808–1809, Elizabeth founded the first house of the Sisters of Charity in Emmitsburg, Maryland, and served as its superior until her death on January 4, 1821.

The College History Series

SETON HALL UNIVERSITY

TOVA NAVARRA

ARCADIA

Published by Arcadia Publishing,
an imprint of Tempus Publishing, Inc.
2 Cumberland Street
Charleston, SC 29401

Printed in Great Britain.

Library of Congress Catalog Card Number: Applied for.

For all general information contact Arcadia Publishing at:
Telephone 843-853-2070
Fax 843-853-0044
E-Mail arcadia@charleston.net

For customer service and orders:
Toll-Free 1-888-313-BOOK

Visit us on the internet at http://www.arcadiaimages.com

"Friendship," said Pooh, "is a very comforting sort of thing." Very sweet, too, an uncanny way of making sense of all the mumbo-jumbo that happens in the human dimension and getting to spiritual dimensions wherein lies the real meaning of it all. If my pal and co-author Margaret Mary Lundrigan had not graced my life, I would surely have missed out on the infinite spectrum of life lessons, adventures, perils (from which we seem always to be rescued), and laughter we continue to share. Margaret, the efforts that went into this book on my alma mater are dedicated to you with love and gratitude.

As for your being a Rutgers and Pace graduate—all is forgiven.

Margaret M. Lundrigan, M.S.W., L.C.S.W.

CONTENTS

ACKNOWLEDGMENTS

Books do not research, write, or produce themselves any more than authors can take all the credit for the finished product. Therefore, I happily offer praise and boundless thanks to my "accomplice," Margaret Lundrigan, for her help with research, production, and the overall preservation of sanity; thanks to Monsignor William Noe Field, university historian and director of the archives; and JoAnn Cotz, associate director of the Special Collections Center, Walsh Library; Monsignor Robert Sheeran, president, for easing my path in the production of this book; the Arcadia staff, who are not only talented but patient beyond reason; Edwin and Judy Havas for their enduring example of Christian ideals; Dr. Petra ten-Doesschate Chu, longtime friend, mentor, and chair of the Art and Music Department; New Jersey author/historian Randall Gabrielan, who encourages my work and finds something to contribute to it, this time a good number of photographic reproductions; Russell Rauch, '54, my ol' newsroom colleague at the Asbury Park Press; Rita Murphy, of Spring Lake; Lisa Grider and Margaret Horsefield of Seton Hall's public relations office; Bill Blanchard, university photographer; all of you, dear readers, who must tolerate the brevity of this volume and understand that this cannot be a complete history, but rather a springboard to appreciating the highlights of this magnificent school; and all the Seton Hall University professors to whom I am indebted for turning my naive interest in the arts into such profound appreciation that it will intimidate me for the rest of my life.

INTRODUCTION

Seton Hall College opened in Madison, New Jersey, in September 1856 with a student body of five young men. By October, enrollment rose to 25. Clearly, the school was on its way.

At this time, the world witnessed many events, including James Buchanan's victory in the U.S. presidential election, the making of the first pure cocaine extract from cocoa beans, the discovery of a Neanderthal skull near Dusseldorf, Germany, and the casting of "Big Ben," the British Houses of Parliament's 13.5-ton bell, at the Whitechapel Bell Foundry. In that year, too, Sigmund Freud, George Bernard Shaw, Oscar Wilde, and Woodrow Wilson were born. Artists such as Jean A.D. Ingres and composers such as Verdi and Berlioz were working unaware of the "new blood" of Impressionism to come just 20 years later. Like all human ventures, Seton Hall emerged, as Dickens would put it in 1859, in the "best of times" and the "worst of times."

Three years after the Rt. Rev. James Roosevelt Bayley, Mother Seton's nephew, became the first Bishop of the fledgling Diocese of Newark and he founded Seton Hall, which was chartered as a college in 1861 and designated a university in 1950. The initial 125-acre South Orange property, on which was a white marble villa, cost $35,000. Rev. Bernard J. McQuaid became Seton Hall's first president, who, among other accomplishments, championed intercollegiate sports and raised funds to replace the mansion with two new buildings after a fire gutted it in 1866. One remains as President's Hall. The other "College Building" succumbed to fire in 1886.

By the time 28-year-old Most Rev. Michael A. Corrigan took over as president in 1868, the Civil War cut enrollment from 119 students in 1868 to 31 by the late 1880s. In 1870, the chapel was dedicated to the Immaculate Conception. Alumni Hall—with a gymnasium, billiard hall, library, and theater—was built in 1883 with $15,000 from the newly formed Alumni Association. Corrigan resigned and his brother, Rev. James H. Corrigan, succeeded him as president from 1876 to 1888, during which time the college celebrated its Silver Jubilee (1881). Seton Hall's fifth president, Rev. William F. Marshall, organized a Spanish-American War reserve unit on campus, and Rev. Joseph J. Synott, who died in 1899, served only two years as the sixth president, during which time the states of Rhode Island and New York began to recognize degrees granted by Seton Hall.

Rt. Rev. Msgr. John A. Stafford, president from 1899 to 1907, saw the school's Golden Jubilee, the ebb of Victorian ways and students driving high-topped automobiles down South Orange Avenue. Rt. Rev. Msgr. James F. Mooney was president from 1907 to 1922, and under his auspices the college survived World War I and a fire in 1909 that devastated the classroom-dormitory building, which was replaced that year by Mooney Hall. Affordable tuition rose only $5 between 1899 and 1922, but the post-war economic slump put the college in property-tax debt for which Mooney obtained $60,000 from the sale of some of the college's land. During the tenure of Rt. Rev. Msgr. Thomas H. McLaughlin, president until 1933, Seton Hall's baseball team was named the "Pirates," and college farm laborer Benjamin Savage died and left a $5,000 insurance policy, the college's first major bequest. That same year, Adolf Hitler became chancellor of Germany and Franklin D. Roosevelt became 32nd president of the United States.

The late 1930s marked the presidency of Rt. Rev. Msgr. James Kelley and the expansion of courses and programs including business and nursing, the founding of several student organizations, and the advent of Seton Hall's coeducational status. Mary Powers of Jersey City became the first female faculty member. State-of-the-art Walsh Gym was built in 1939. In the 1940s and early '50s, nine out of ten Seton Hall students were World War II veterans. Corrigan Hall was built to help accommodate them.

In 1950, President John L. McNulty directed that Seton Hall be restructured into four schools—Arts and Sciences, Business, Education, and Nursing—with university status awarded by the New Jersey State Legislature. The School of Law emerged the next year, with Miriam Rooney as dean. Rooney was the first woman admitted to practice before the U.S. Supreme Court and the country's first woman dean of law. The centennial in 1956 received the attention of President Dwight D. Eisenhower. The campus radio station was well established, and star athletes such as Walter Dukes and Andy Stanfield stepped into the limelight. Weathering Vietnam, protests, and social change of the late 1960s, the university had segued nicely into full coeducational status and important cultural growth in the 1970s that fostered the Asian Studies Center and what is now the Center for African-American Studies, Upward Bound, the Puerto Rican Institute, the W. Paul Stillman School of Business, and the Caroline De Donato Schwartz College of Nursing. In 1975, St. Elizabeth Ann Bayley Seton was canonized.

Hazard Zet Forward always in mind, the 1980s heralded much movement, including an educational exchange program with the People's Republic of China and the construction of the $5 million Robert E. Brennan Recreation Center. Alumnus and Regent Brennan donated the first $1 million. As Board of Regents chairman in 1989, he pledged $10 million toward the school's new capital campaign. The Immaculate Conception Seminary moved from Darlington, New Jersey, to the campus in 1984, and three new residence halls went up as well. In 1987, the School of Graduate Medical Education was established, and the Prep school ended its affiliation with the university and moved to West Orange. University Chancellor and architect Dr. John J. Petillo set the "Seton Hall Renaissance" of the 1980s in motion, and in the ever-evolving sports arena, head coach P.J. Carlesimo led his basketball Pirates to the NCAA Final Four in Seattle, which they lost by one point. Nonetheless a marvel, the team made headlines and created excitement for alumni far and wide.

This past decade? The Seton Hall Touring Choir performed several concerts in Italy, including one for Pope John Paul II. Father Thomas R. Peterson, O.P., became university chancellor, and a five-year Seton Hall Campaign to raise $100 million for scholarships, faculty development, and a new library is under way. The university's revised mission statement of 1996 emphasizes that "Seton Hall is a major Catholic university. In a diverse and collaborative environment it focuses on academic excellence and ethical development. Seton Hall students are prepared to be leaders in their professional and community lives in a global society and are challenged by outstanding faculty, an evolving technologically advanced setting and values-centered curricula."

President Msgr. Robert Sheeran gave the first State of the University Address in 1997, sharing his vision of how his alma mater is becoming "the paradigm of the Catholic university of the new millennium." He believes Seton Hall offers "an integrated learning experience of the mind, heart and soul." Walsh Library holds nearly 500,000 volumes, and the six-story, 126,000-square-foot Kozlowski Hall, an academic center, boasts a 390-seat auditorium and distance-learning technology. More than 40 majors, minors, certificates, interdisciplinary, and other special programs make up the undergraduate level, while the graduate level offers 47 degree programs in the College of Arts and Sciences, Stillman School of Business, College of Educational and Human Services, the College of Nursing, the School of Graduate Medical Education, the School of Law, the Seminary and School of Theology, and University College.

"It grew some," a punster might say. One of the best synopses of Seton Hall's influence comes from Rev. Msgr. Edward J. Fleming, '40, Ph.D., LL.D.: "The happiest days of all my life—as a student, teacher and administrator—have been here at Seton Hall."

One

GENESIS AND THE
FORMATIVE YEARS

We lead timid lives, shrinking away from difficult tasks till perhaps we are forced into them or ourselves determine them, and immediately we seem to unlock the unseen forces. When we have to face danger, courage comes, when trial puts a long-continued strain upon us, we find ourselves possessed with the power to endure Common experience teaches that . . . every danger or difficulty brings its own strength

—J.A. HADFIELD, THE PSYCHOLOGY OF POWER

The chief corporal works of mercy are seven: To feed the hungry. To give drink to the thirsty. To clothe the naked. To visit the imprisoned. To shelter the homeless. To visit the sick. To bury the dead The chief spiritual works of mercy are seven: To admonish the sinner. To instruct the ignorant. To counsel the doubtful. To comfort the sorrowful. To bear wrongs patiently. To forgive all injuries. To pray for the living and the dead.

—REV. MICHAEL A. McGUIRE, THE NEW BALTIMORE CATECHISM AND MASS, 1953

Every teacher will offer you wisdom you can use, as well as ideas you do not understand, agree with, or wish to employ. Take the best and leave the rest. There is a nugget of good in every experience. Receive what God wants you to have, and let Spirit take care of the rest.

—ALAN COHEN, A DEEP BREATH OF LIFE

Love is the strongest force in the universe. When given correctly, it unifies and builds, defends and protects. It is a concentrated energy that has no boundaries. True love is never jealous or possessive, nor does it have conditions. I think that we experience life after life to learn about love and see it manifest in different circumstances. How else could we appreciate the many facets of our being?

—JAMES VAN PRAAGH, REACHING TO HEAVEN

It is more difficult to find a good college president than to find a good anything else in the world. All that the College needs to insure its permanent prosperity is a president. Everything else is there.

—FROM THE DIARY OF THE MOST REVEREND JAMES ROOSEVELT BAYLEY, JULY 16, 1959

Sister Sparrows, Sister Doves, consider what gifts God has bestowed upon you: He gave you wings so fast you might travel through the air, and down to keep you warm in wintertime; He scattered many kinds of nourishment over the ground and in the trees so that you would not go hungry; He filled your breasts and throats with song.

—NIKOS KAZANTZAKIS, SAINT FRANCIS

Let God's truth be our guide.

—ST. ELIZABETH ANN SETON

Born in 1814, Most Reverend James Roosevelt Bayley, first Bishop of Newark and founder of Seton Hall College, was proud of his lineage that included the names Bayley, Roosevelt, and Seton. His father, Dr. Guy Carleton Bayley, and grandfather, Dr. Richard Bayley, ranked among America's earliest prominent physicians. His maternal grandfather, James Roosevelt, was the great-grandfather of President Franklin Delano Roosevelt. In honor of his beloved aunt, St. Elizabeth Ann Bayley Seton, founder of the first American community of the Sisters of Charity in 1809, Bishop Bayley named Seton Hall College. A man of many achievements, he was first ordained as an Episcopal minister and converted to Catholicism in 1842. Ordained a priest in 1844, Bayley served in several posts, including as Archbishop of Baltimore from 1872 to 1877. He died October 3, 1877, after two months of illness and, as he wished, is buried beside his famous aunt in Emmitsburg, Maryland.

The seal of Seton Hall College, adopted on May 17, 1864, bears the mottos *Religioni ac Bonis Artibus, Per Fidem Non Per Speciem* ("Through faith and not through resemblance"), and *Hazard zit Forward* ("No matter what the hazard, yet forward"). The image of Our Lady Seat of Wisdom derives from the Seal of the Pontifical College of Propaganda in Rome, and on the left is the Episcopal Arms of Bishop Bayley, who credits Mother Seton's influence for his conversion to Catholicism.

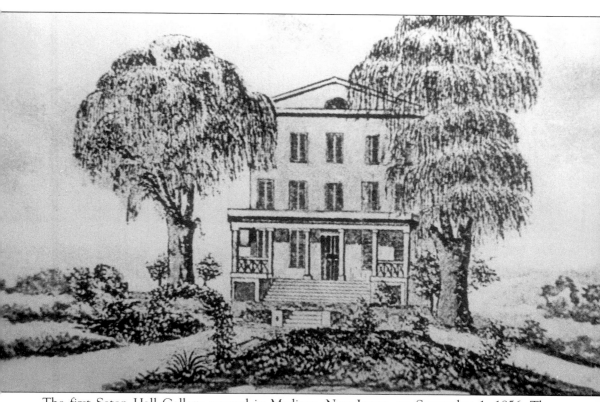

The first Seton Hall College opened in Madison, New Jersey, on September 1, 1856. The building had been a Young Ladies' Academy under the direction of Madame Chegary.

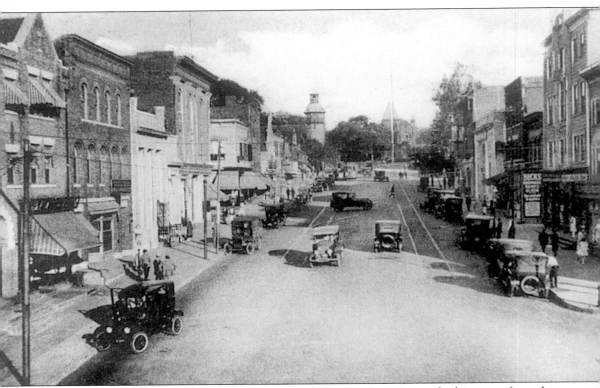

This is a view of South Orange Avenue, in South Orange, New Jersey, looking east from the railroad, early 1900s. This photo makes one realize in dramatic fashion how much the times change the essence of a community.

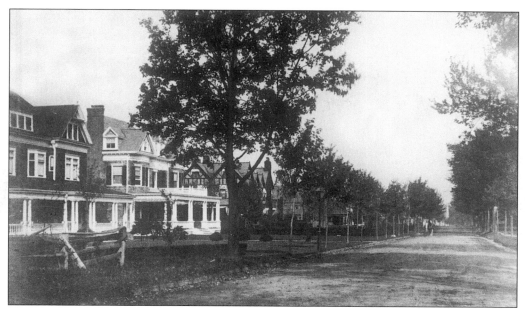

Center Street, South Orange, New Jersey in 1899 boasted beautiful homes and trees.

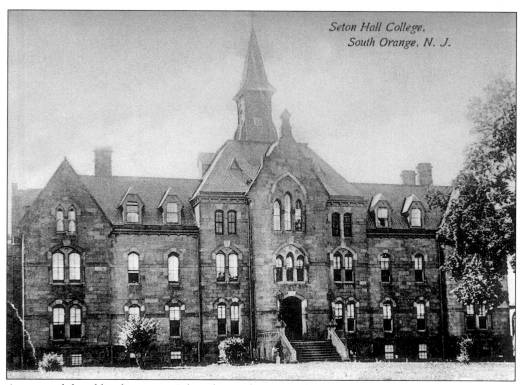

Seton Hall College,
South Orange, N. J.

A postcard dated by the writer, Edward R. Fish, as March 29, 1906, features the building that is President's Hall on campus.

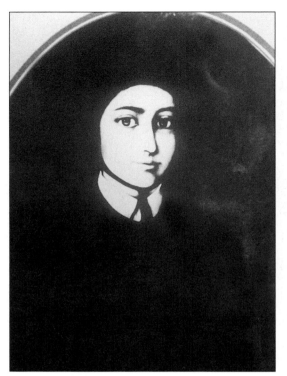

Mother Seton was born into the Episcopal faith on August 28, 1774, in New York City. At 20, she married banker William M. Seton, who died in Italy in 1803, leaving his wife and five children. After his death, Elizabeth stayed in Italy with the devout-Catholic Filicchi (spelled as Felici in the "Memoirs of Msgr. ('Doc') J.F. Kelley," 1987) family. Back in the United States, in 1805, Elizabeth converted to Catholicism, which resulted in estrangement from her relatives. She went on to found America's first Catholic school in 1808, and in 1809 established the first American order of the Sisters of Charity. Mother Seton died at age 46. She was canonized in 1975, after three miracles (cures from disease) were attributed to her. Robert Seton, her grandson, lectured on sacred archeology at the college during the late 1800s. Billed as "a fabulous character" in *The Centennial Story of Seton Hall University*, Seton was the first American to be designated a Monsignor. At the time of his death, he was a titular Archbishop.

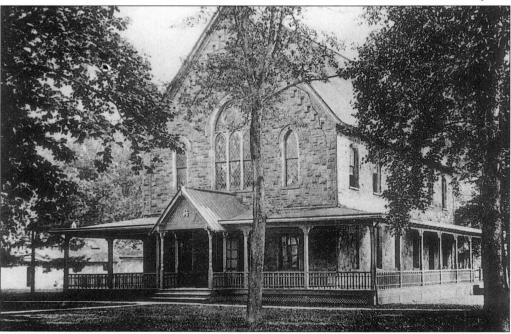

Alumni Hall, 1887, is now the seminary, chapel, and offices. Postcards of campus scenes seem to have been a popular and quick way for students to communicate with their friends and relatives while immersed in their studies.

The two gentlemen sitting on the steps blend into the idyllic wooded scene of the entrance to Seton Hall College, 1899.

The campus entrance in 1906 was graced by trees that, according to Msgr. William Noe Field, university archivist, were cut down during the presidency of Bishop John J. Dougherty in the late 1950s into the '60s. Dougherty preferred open space landscapes, but Msgr. Field said so lush and beautiful were the trees that one could walk under them in the rain and not get wet.

Rev. William F. Marshall, was the fifth president of Seton Hall from 1888 to 1897. Vice President and Treasurer Marshall succeeded Rev. James H. Corrigan (1844–1891), who presided from 1876 to 1888, during which time the college both celebrated its Silver Jubilee and suffered a fire in the college building in 1886. Alumni Hall was restored and reopened as classrooms and dormitories by 1888. It was to burn a second time in 1909.

"Spring Grove," Seton Hall campus in 1899, became the site of McLaughlin Library.

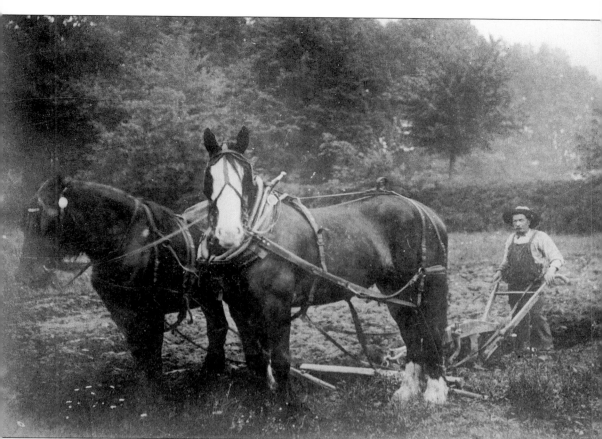

"A Short Rest," 1899, portrays Benny Savage, who worked the farm when Seton Hall had cattle and crops. As recorded in the Minutes of the Board of Trustees of May 17, 1934, Mr. Benjamin Savage left the college $10,719.83, the residue of his estate. It was the school's first major bequest. In the Winter 1991 issue of *Seton Hall University Magazine*, Carol Tichenor Macken wrote that Savage's policy was worth $5,000, and "today, a special society recognizing those who have made planned gifts to Seton Hall bears his name, The Benjamin Savage Society."

This is an early campus scene entitled in the archives as "Fairy Glen," 1899, the year Rt. Rev. John A. Stafford became Seton Hall's president.

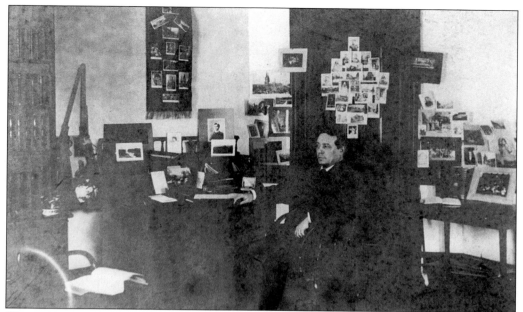

"Yours Very Sincerely," was probably a *c.* 1900 faculty office. Notice the collection of photographs and the two rifles adorning the teacher's desk. The teacher is unidentified in the university's archives.

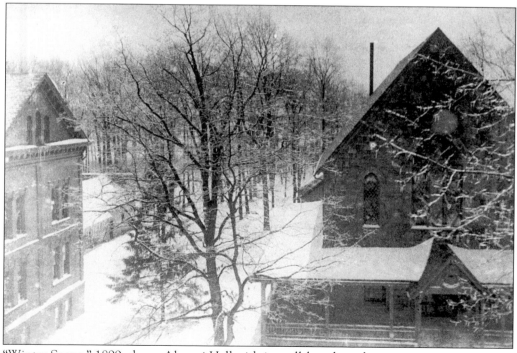

"Winter Scene," 1899, shows Alumni Hall with its well-loved porch.

Stafford Hall burned three times. Each time a new roof was put over what was left. The basement served as the college dining room, athletic "sweat" room, and the "day-hops" (commuter students) cafeteria. Architect Jeremiah O'Rourke designed Stafford Hall, the Marshall Library, the administration building, President's Hall, and the chapel. To the rear you can see the library as it was in 1895.

The new dormitory evolved into Seton Hall Preparatory School, the building named for Msgr. James Mooney, president of the college from 1907 to 1922. Mooney eventually sold half the campus' land to a builder, Becker Better Built Homes. Mooney Hall holds a soft spot in this writer's heart because of the three years spent largely in Mooney Hall classrooms, teaching art and music to the Prep boys.

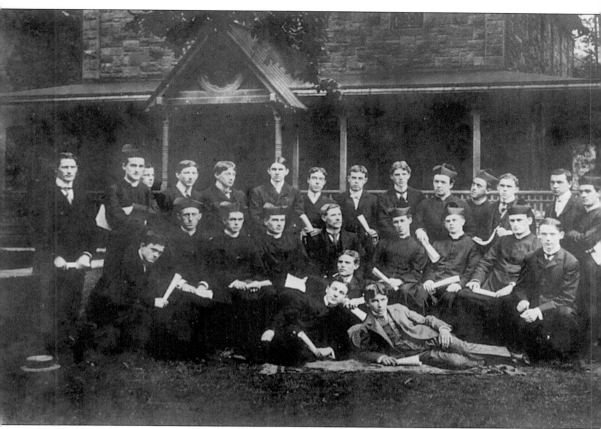

Early graduation ceremonies were held in Alumni Hall, with its porch and quadrangle.

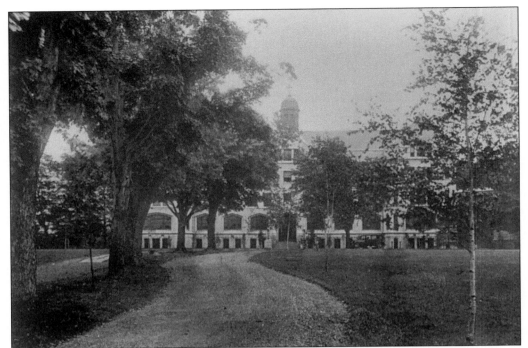

Mooney Hall was built in 1909, and it served as Seton Hall Preparatory High School until the university and the Prep parted and the Prep moved to West Orange, with Father Michael Kelly as headmaster.

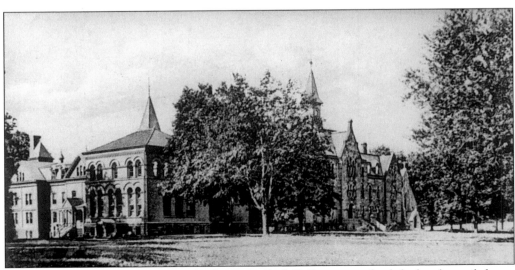

A postcard of the campus shows the large Stafford Hall spire at the left that burned down. Stafford Hall and Marshall Library are featured here.

Actor John Barrymore in 1903—known to America as "The Great Profile"—was one of Seton Hall's most illustrious alumni, along with his brother Lionel. John's legendary escapades included attempts to burn down campus buildings, according to "Historic Setonia," compiled and edited by Joseph A. Moore, class of 1951.

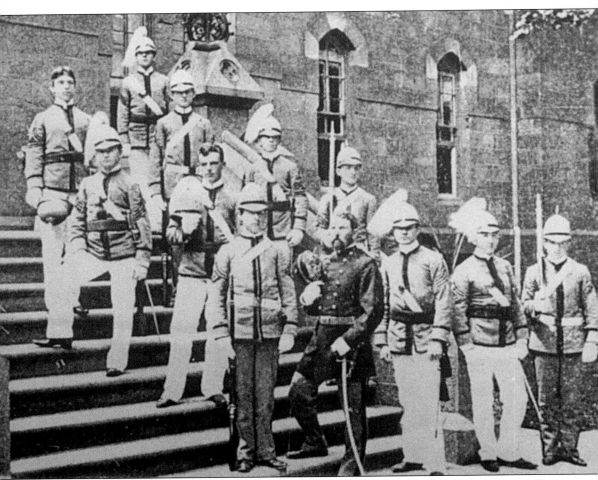

Cadet officers of 1898 are pictured here with Lt. W.C. Rafferty of the United States Army. Rev. William F. Marshall introduced military instruction and drilling to the college. Sen. James Smith, a trustee of the college, secured an officer from the Army in 1893 to head the cadets. "The military department of the college was formally established by the detailing of Lt. Michael J. Lenihan of the 20th Infantry, who went on to become a brigadier-general. The cadets were organized under the professor of Military Science Tactics," according to the June 4, 1931 issue of "The Setonian." The military department was suspended at the outbreak of the Spanish-American War in 1898.

This view is of Grove Road in South Orange, 1899.

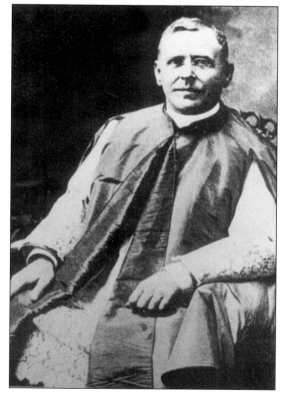

Born in March 1859, the Rt. Rev. Msgr. John A. Stafford, S.T.L., was appointed by the Rt. Rev. Winand M. Wigger, Bishop of Newark, to the seventh presidency of Seton Hall upon the death of Dr. Synnott. Msgr. Stafford served until 1907, when he was appointed Rector of the Church of St. Paul of the Cross in Jersey City. The Infirmary and Sisters' House, the Sacred Heart Oratory, the brownstone cloister uniting the administration building with the chapel, and embellishment of the chapel are credited to his term as president. He died as Rector of St. Patrick's in Jersey City in 1913.

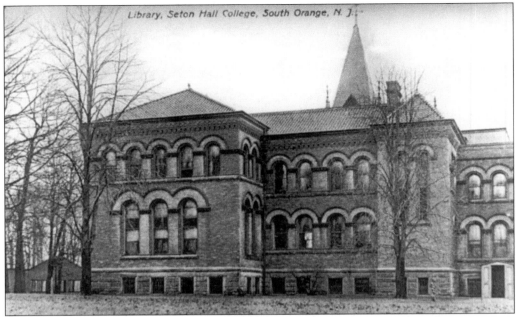

Msgr. Field said the architect of the Marshall Library was "gone on Gothic, then went into Italian Renaissance style, then back to Gothic."

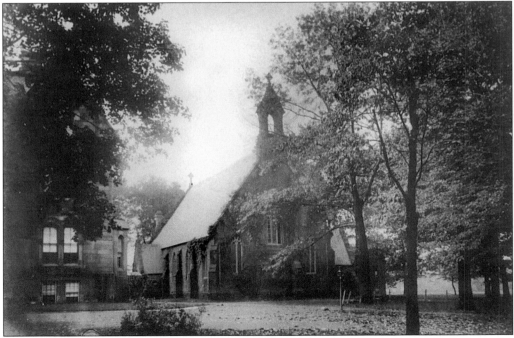

This photograph shows the chapel before it was remodeled in 1922. A "bridge" attaching the chapel with the administration building was added later.

Changing Lifestyles

Up at 4 a.m., Silence in the Halls, But Parking Wasn't a Problem

Today's Seton Hall students moan about high tuition, no parking spaces, and lousy food. Student life in the early days of Seton Hall was quite different. Among other things, students had to contend with silence rules and Saturday classes.

When the first students arrived on campus they were supplied with clothing for the semester. Each received the three winter suits, 12 shirts, 12 pairs of stockings, 12 pocket-handkerchiefs, three pairs of shoes and an overcoat. A student provided his own silver spoons, forks and a napkin ring marked with his name.

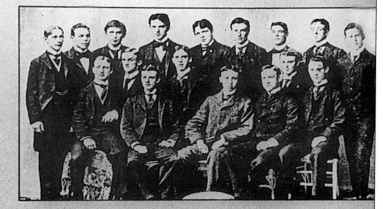

The academic year consisted of two sessions of five months. The last Wednesday in August marked the start of the school year and it concluded on the last Wednesday of June. The only vacation within this period were 10 days at Christmas and two days in May.

Board and tuition, washing, mending, and use of bed and bedding cost $225 per year. Students were charged an additional $5 for doctor's fees.

4 a.m. was the rising time for students and faculty alike.

Professors, tutors, and students were read weekly reports on the progress of all classes. Parents were also sent progress reports following the end of each academic session. The student's grades were also read publicly.

Rules of discipline called for the expulsion of students who left college grounds after nightfall. The use of tobacco was forbidden. A rule of silence forbade any talking in the class corridors. No correspondence was permitted except with parents or guardians. The president had the right to examine all letters.

If a student was absent from a class, he had to present a written excuse upon his return to class. Attendance was required nine-tenths of the year, and tardiness counted as half an absence.

Parents were strongly urged to place their son's spending money with the college treasurer to "be given as prudence suggests." The treasurer kept a ledger of every penny spent by the student.

The entire college went to school on Saturday and Thursday was substituted as the day off. On their days off students were permitted to "take walks in the surrounding country, in small bands accompanied by a prefect."

Maybe hunting for a parking space isn't so bad after all. ▲

These members of the Class of 1895 lived an entirely different lifestyle than today's college students with extremely close supervision and tight discipline the order of the day.

A page from a yearbook features a photograph of the Class of 1895 and offers amusing insight into early campus life.

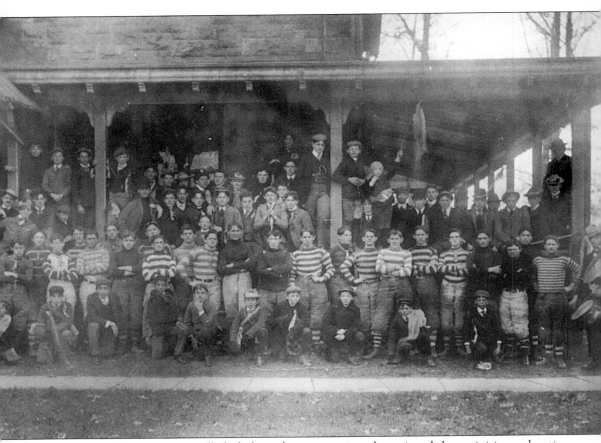

The "football team"—actually kids from the community who enjoyed the activities and antics on the campus field—pose on the porch of Alumni Hall in 1899. These players were endearingly called "The Horribles and the Terribles."

The lawn and tennis field, 1899, was the site of the future McLaughlin Library, built in 1954.

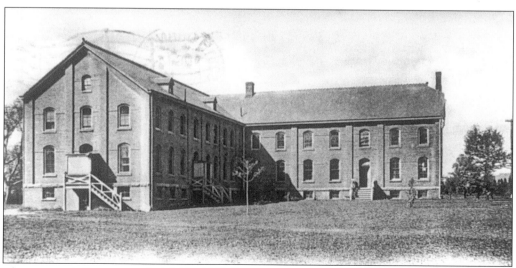

The campus infirmary was in McQuaid Hall.

A view of South Orange Avenue, 1899, emphasizes the majestic air of the campus surroundings.

Rev. Joseph J. Synnott, D.D., the sixth president from 1897 to 1899, was born in 1863. A man of extraordinary modesty, industry, and intelligence, Dr. Synnott upgraded the high school department according to the State Department of Education and the Regents of New York. He also secured New York and Rhode Island recognition of degrees conferred by Seton Hall College, and foresaw the need for continuing education for professors. His term was cut short by his sudden death in March 1899. A graduate of St. Francis Xavier College in New York and the Imperial University in Innsbruck, Austria (where he earned his Degree of Doctor of Theology), he was mourned by everyone.

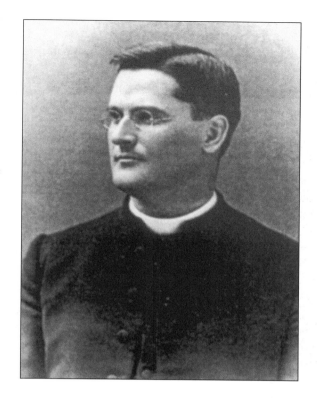

A "North View of College," 1899, shows the administration building, chapel, and trees.

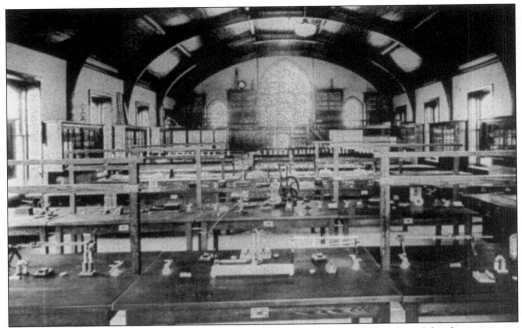

This is an early view of the Alumni Hall Science Laboratories, now the chapel for the seminary.

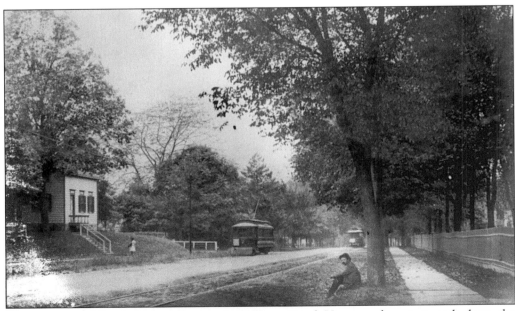

This is a view of South Orange Avenue from Grove Road. Horses and carriages rode down the middle of the street, while trolleys ran close to the sidewalks.

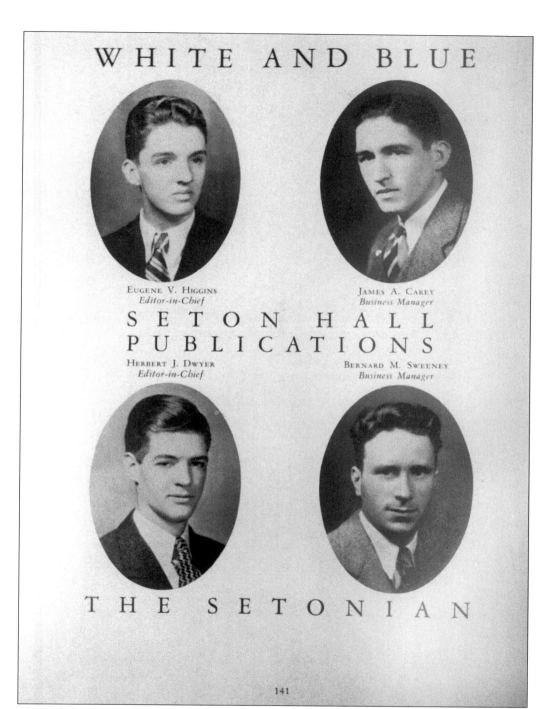

WHITE AND BLUE

EUGENE V. HIGGINS
Editor-in-Chief

JAMES A. CAREY
Business Manager

SETON HALL
PUBLICATIONS

HERBERT J. DWYER
Editor-in-Chief

BERNARD M. SWEENEY
Business Manager

THE SETONIAN

141

The early yearbooks, called *The White and Blue* in honor of the school's colors, eventually were renamed *The Galleon*. The class of 1924 inaugurated the custom of the college's yearbook. *The White and Blue's* first editor was Francis J. Walsh. In the 1926 yearbook was a noteworthy platitude: "What is writ, is writ; would it were worthier." Above is a page from the 1930 *White and Blue*.

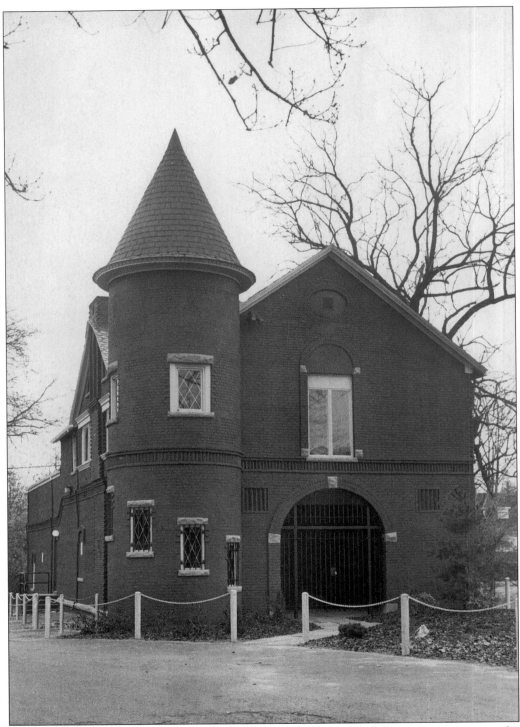

The modern Seton Hall University Art Center was installed in an 1887 carriage house near the modern entrance gates of the campus.

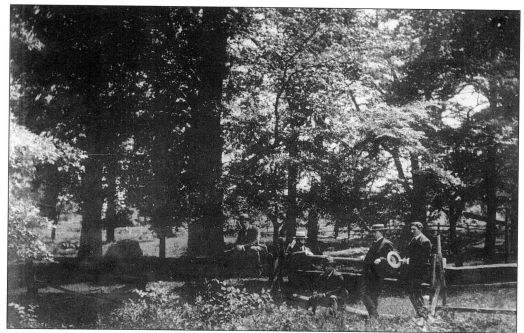

"Mid Cooling Shades," 1899, was one of the titles given to turn-of-the-century photographic tableaux.

Here is Alumni Hall, embraced by nature.

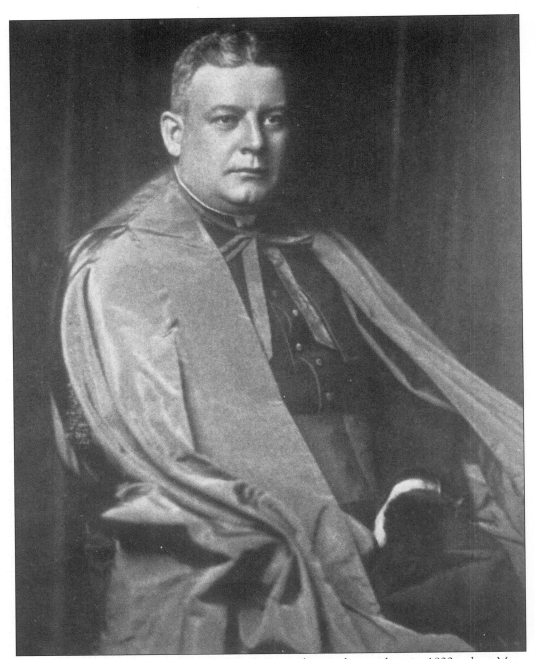

Rt. Rev. Thomas H. McLaughlin, S.T.D., became the ninth president in 1922, when Msgr. Mooney retired. He had to confront the reconstruction period after the war, during which hundreds of young veterans sought admission, as well as the Church's demand that the secular college separate from the seminary. The grammar school was closed, too, but the high school acquired its own staff distinct from that of the college. Born in 1873 and ordained in 1900, Msgr. McLaughlin became Rector of the Seminary. Msgr. McLaughlin's service and connection to the college had been uninterrupted since 1908. He died March 17, 1947.

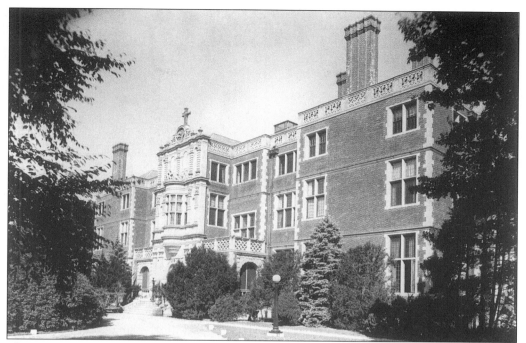

The original seminary in Darlington, New Jersey, was built in 1905 by Charles Crocker, of the First Trans-Continental Railway. The architect was John Bright, who created an exact copy of Bramshill Palace in England. Each room inside replicated rooms in English palaces. The building served later as campus housing. The seminary returned to the campus in 1982–83.

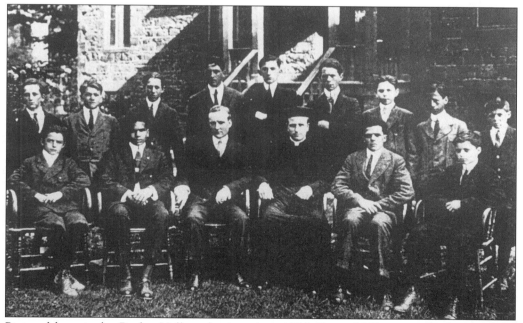

Pictured here is the Bayley Hall graduating class, 1914. Seton Hall eventually dissolved the grammar school and established a separate high school, Seton Hall Preparatory School for boys.

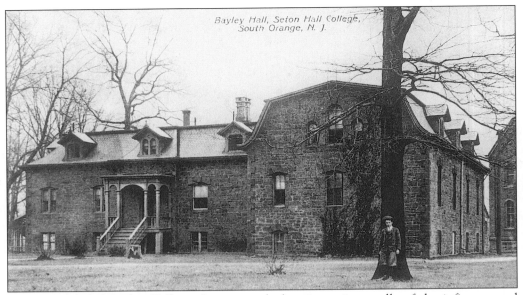

Although labeled Bayley Hall on this postcard, the picture is actually of the infirmary and grammar school. The building was destroyed and replaced by McQuaid Hall, now the School of Diplomacy, which had earlier been a convent, infirmary, and athletic dormitory.

Four priests create a "tableau," a popular staged composition for early-20th-century photographs. On the right is Bishop John J. O'Connor.

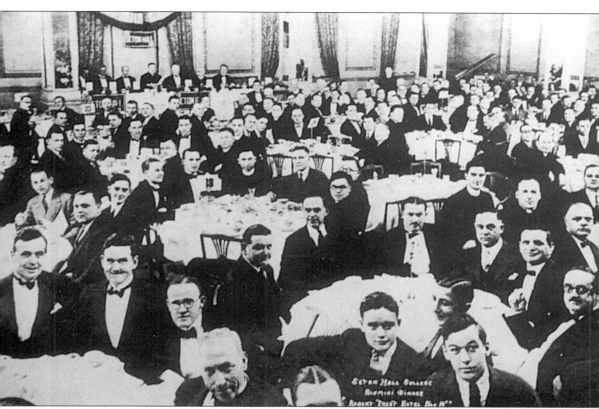

The Seton Hall College Alumni Dinner, November 1925, met at the Robert Treat Hotel in Newark.

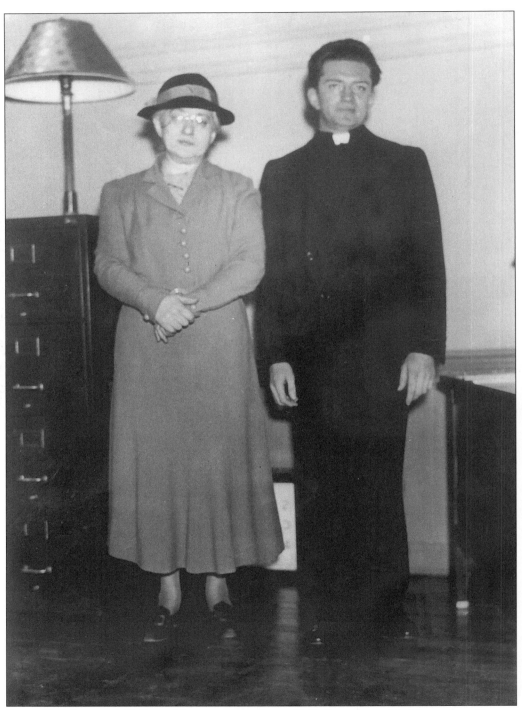

Seton Hall Prep and College Alumnus Msgr. James F. Kelley poses with his mother, Frances Shaw Kelley, on July 8, 1928, when he was ordained.

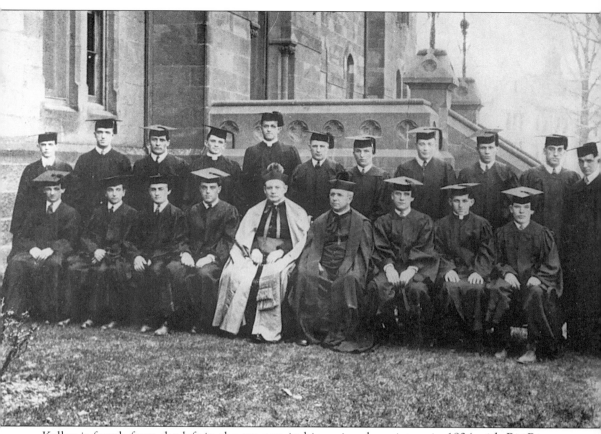

Kelley is fourth from the left in the top row in his senior class picture in 1924 with Rt. Rev. Thomas H. McLaughlin, S.T.D.

The college orchestra, 1924–25, performed at college functions.

Father Robert Daly poses (left) with three fellow seminarians.

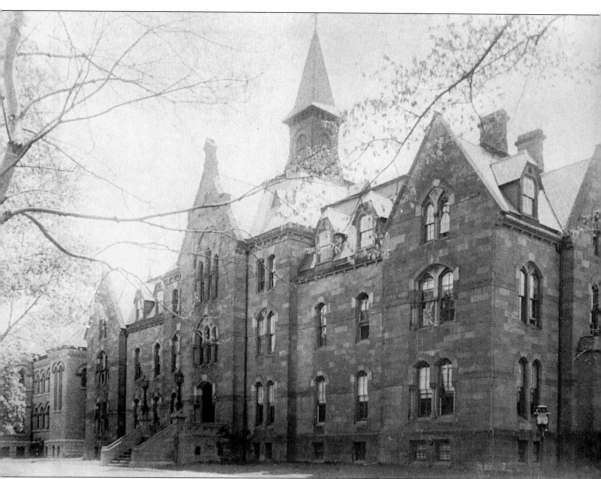

President's Hall, before its entrance was enclosed by glass doors, emanates majesty and scholarship. In 1996, the titles of president and chancellor were separated into two positions. Past presidents and chancellors of Seton Hall through June 1990 are as follows: Most Reverend Bernard J. McQuaid, D.D., 1856–1857; Reverend Daniel J. Fisher, D.D., 1857–1859; Most Reverend Bernard J. McQuaid, D.D., 1859–1867; Most Reverend Michael A. Corrigan, D.D., 1867–1876; Reverend James H. Corrigan, D.D., 1876–1888; Reverend William F. Marshall, D.D., 1888–1897; Reverend Joseph F. Synott, D.D., 1897–1899; Right Reverend John A. Stafford, S.T.L., 1899–1907; Right Reverend James F. Mooney , D.D., L.L.D., 1907–1922; Most Reverend Thomas H. McLaughlin, S.T.D., 1922–1933; Most Reverend Francis J. Monaghan, S.T.D., 1933–1936; Right Reverend James F. Kelley, Ph.D., 1936–1949; Right Reverend John L. McNulty, Ph.D., L.L.D., 1949–1959; Most Reverend John J. Dougherty, S.S.D., L.L.D., S.T.D., L.H.D., 1959–1969; Reverend Monsignor Edward J. Fleming, Ph.D., L.L.D. (acting president), 1969; Reverend Monsignor Thomas G. Fahy, Ph.D., 1970–1976; John A. Cole, M.B.A., L.L.D. (acting president), 1976–1977; Robert T. Conley, Ph.D., 1977–1979; Robert Laurence T. Murphy, M.M., Ph.D., 1979–1980; Edward R. D'Alessio, Ph.D. (chief operations officer), 1980–1981; Edward R. D'Alessio, Ph.D., 1981–1984; John J. Petillo, Ph.D. (chancellor), 1984–1989; Reverend Monsignor Dennis J. Mahon, Ph.D. (acting chancellor), 12/88–4/89; Reverend Monsignor Richard M. Liddy, S.T.L., Ph.D. (acting chancellor), 1/90–6/90; Very Reverend Thomas R. Peterson, O.P., October 1991–present (1999).

The college and seminary building, now President's Hall, was built in 1870 and photographed *c.* 1900. In the 1939 Galleon it says: "Herein lies grim authority." (Cover.)

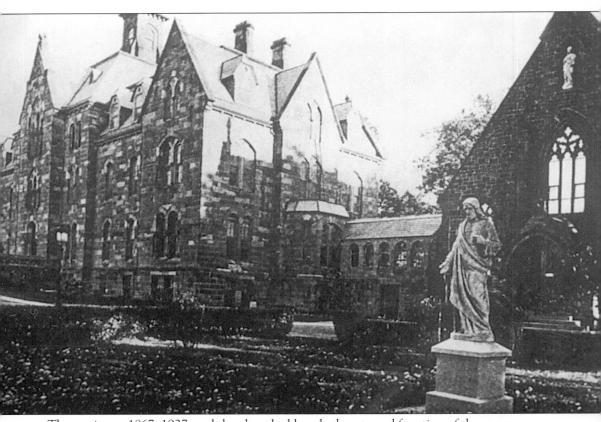

The seminary, 1867–1927, and the chapel add to the beauty and function of the campus.

Two
HAZARD ZET FORWARD
DESPITE THE ODDS

The purpose of Seton Hall is to impart a good education in the highest sense of the word—to train the moral, intellectual and physical being. The health, manners and morals of the pupils are an object of constant attention. The system of government is mild and paternal, yet firm in enforcing the observance of established discipline.

—REV. BERNARD J. MCQUAID, FIRST PRESIDENT, 1862

A professor is one who talks in someone else's sleep.

—W.H. AUDEN

*The Angel that presided o'er my birth
Said, 'Little creature, formed of joy and mirth,
Go, love without the help of anything on earth.'*

—FROM "RICHES" BY WILLIAM BLAKE

When you are a Bear of Very Little Brain, and you Think of Things, you find sometimes that a Thing which seemed very Thingish inside you is quite different when it gets out into the open and has other people looking at it.

—A.A. MILNE, WINNIE-THE-POOH

If for my little alms God has made me Supreme Pastor of His holy Church, and has sent me an angel to help me, what will He not grant me if I set to work to perform with my whole strength whatever he wishes of me!

—POPE SAINT GREGORY THE GREAT

Go confidently in the direction of your dreams! Live the life you've imagined. As you simplify your life, the laws of the universe will be simpler; solitude will not be solitude, poverty will not be poverty, nor weakness weakness.

—HENRY DAVID THOREAU

Speak the truth. Do your duty. Do not neglect the study of the scriptures. Do not cut the thread of progeny. Swerve not from truth. Deviate not from the path of good. Revere greatness If at any time there is any doubt with regard to right conduct, follow the practice of great souls, who are guileless, of good judgment, and devoted to truth. Thus conduct yourself always. This is the injunction, this is the teaching, and this is the command of the scriptures.

—FROM "TO A LAY STUDENT," THE UPANISHADS

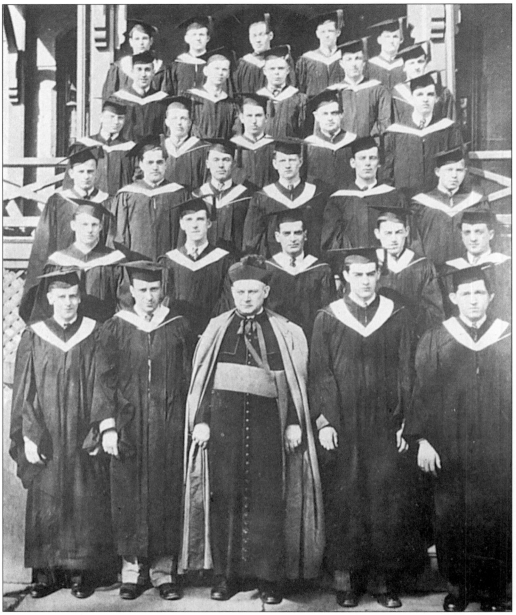

The graduating class of 1930 poses for this photograph with College President Thomas McLaughlin in the center. The Rt. Rev. Msgr. McLaughlin was president until 1933.

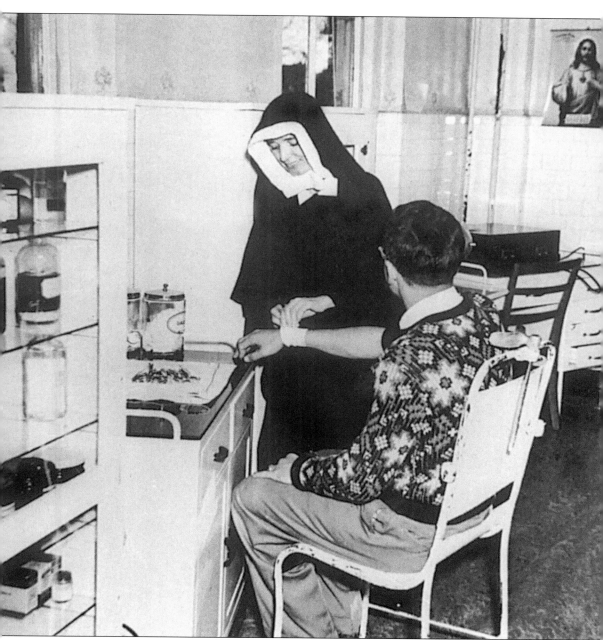

Sister Elise bandages a student's wrist in the infirmary in McQuaid Hall.

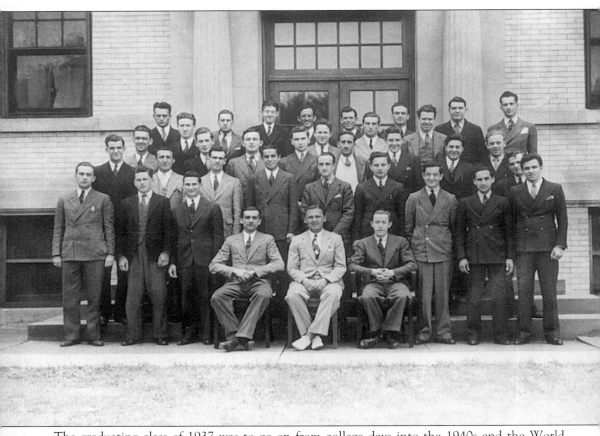

The graduating class of 1937 was to go on from college days into the 1940s and the World
War II years.

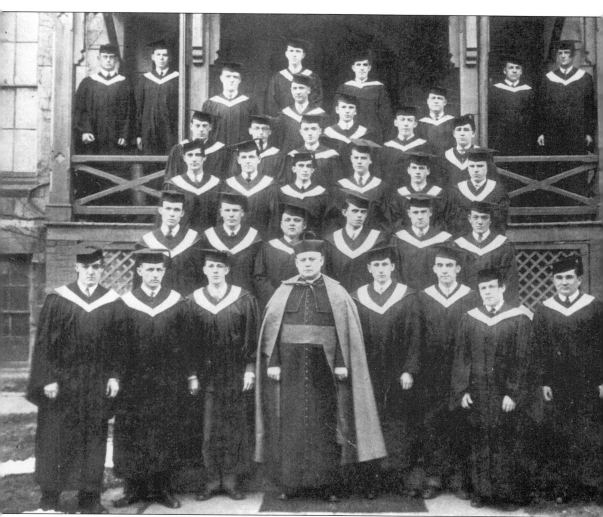

Bishop McLaughlin is pictured here with the faculty in 1934.

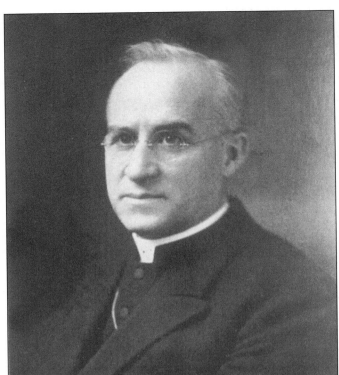

Rt. Rev. Thomas J. Walsh, D.D., was president of the Board of Trustees.

Msgr. Fleming's brother, in the white suit, became a physician; he is pictured above, along with the class of 1933–34.

This is a formal portrait of Msgr. Kelley, who wrote *Memoirs of Msgr. ("Doc") J.F. Kelley*, which he published in 1987. According to the 1987 edition, copies are available through Adrian McBride, 157 Locust Point Road, Locust, NJ 07760.

Msgr. Kelley is pictured here with the Bayley-Seton League, the ladies' auxiliary, 1936–38.

Historical Milestones

1856–Seton Hall College opened at Madison, New Jersey.
1860–Purchase of the Elphinstone property in South Orange.
1861–College incorporated by the State of New Jersey.
1862–Awarding of the first A.B. Degree to Louis Edward Frith.
1863–First intercollegiate baseball game against Fordham.
1864–Corporate seal adopted.
1866–Fire destroyed main building.
1867–Construction of Presidents Hall.
1870–Completion and dedication of Chapel.
1877–Tuition reduced from $450 to $380 per annum.
1879–Alumni Association organized.
1883–Alumni Hall cornerstone laid—original building included a gymnasium, billiard hall, library and theater.
1886–Fire once again destroys the main building of College.
1893–Establishment of courses in military instruction.
1897–Separation of Seton Hall Prep curriculum from College curriculum.
1898–College erected new library at a cost of $35,000, with a collection of 18,000 volumes.
1903–Seton Hall entered basketball team into intercollegiate competition.
1905–First use of the current baseball field.
1909–Fire destroyed old classroom and dorm buildings.
1910–Mooney Hall opened.
1913–Bayley Hall erected, housed grammar school until 1926.
1922–Sale of all land on north side of South Orange Avenue (farm).
1923–Arts & Sciences organized into departments, first courses in teacher training offered.
1924–Setonian and yearbook began publication.
1926–Offering of pre-medical program; now three curricula: Classical, Scientific, and Pre-Medical.
1927–Seminary moves to Darlington.

Continued on page 60.

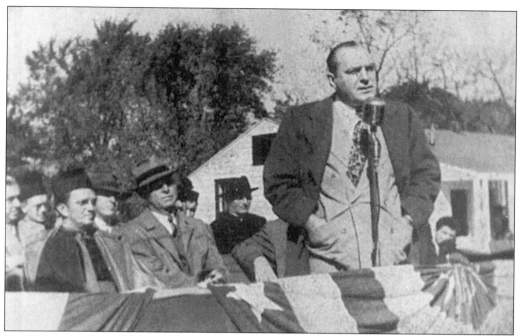

In 1946, actor Pat O'Brien addresses the audience at a gathering honoring Seton Hall war heroes.

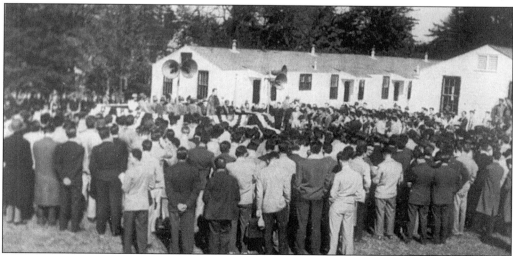

Msgr. Kelley eulogizes Seton Hall war heroes. There were 13 buildings dedicated in 1946 to house veterans who enrolled as Seton Hall students. The vets comprised 94 percent of the student body.

Rt. Rev. Msgr. James F. Mooney, D.D., LL.D., eighth president from 1907 to 1922, served the longest term of all the previous presidents. Mooney Hall opened in 1910.

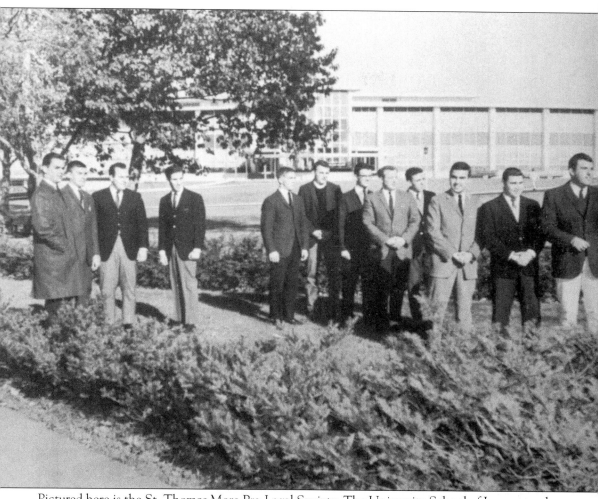

Pictured here is the St. Thomas More Pre-Legal Society. The University School of Law opened in 1951, with Miriam Rooney as the first woman dean of law in America.

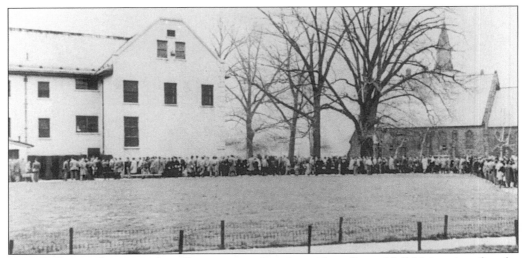

Msgr. Kelley made certain that all veterans wishing to study at Seton Hall University after the war were accepted without question.

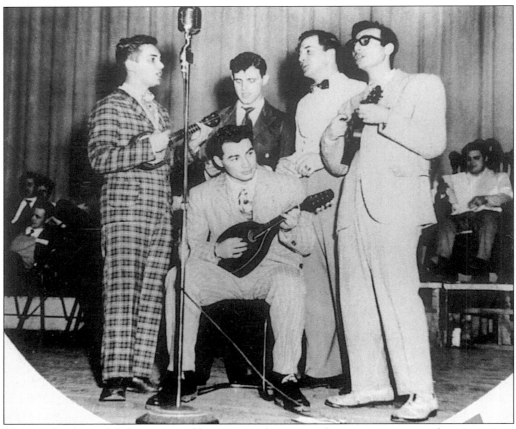

This yearbook candid shows a vocal/instrumental group performing at a campus function.

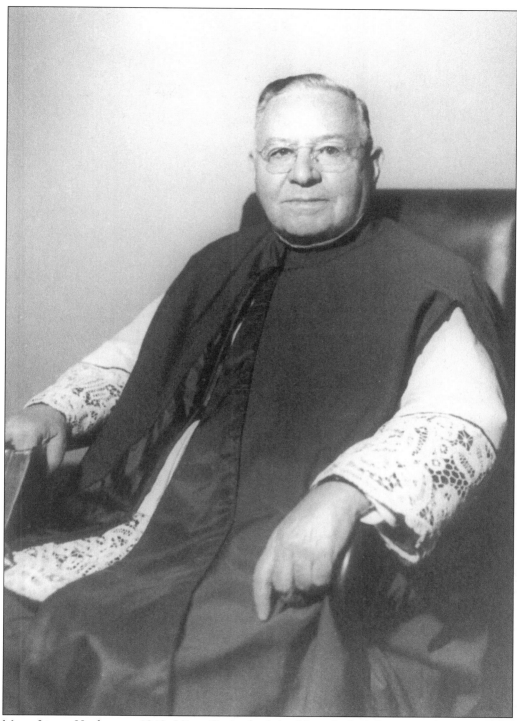

Msgr. James Hughes, *c*. 1940, Vicar-General of the Newark Archdiocese and pastor of St. Aloysius in Jersey City, was also on the Seton Hall Board of Trustees.

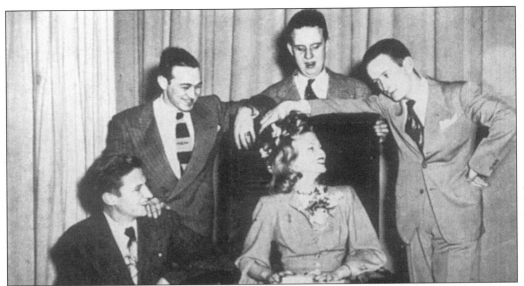

Surrounding Doris Steiger, "Queen of the Campus," are Setonian staff members John Mielach, Sy Tepperman, Tom Bay, and Donn Huber.

1931–The nickname, Pirates, given to the school after a 5-run, 9th-inning rally brought a 12-11 victory over Holy Cross, prompting a local sports writer to say "That Seton Hall team is a gang of Pirates."1932–Accreditation by Middle States Association.

1933–Seton Hall joined Association of American Colleges and American Council on Higher Education.

1933–All sports programs dropped (basketball returns in 1935).

1933–Benny Savage, a long-term employee on the Seton Hall farm, died leaving an insurance policy of $50,000 to Seton Hall, the first major bequest in the School's history.

1936–First courses in accounting, finance, international trade, business law, electives.

1937–Founding of Brownson Debate Society.

1937–Newark extension division opened, admitting women for the first time (Mary Grace Dougherty registered as first woman student).

1937–Jersey City Extension Division opened first summer session.

1938–Bayley Seton League founded.

1939–Cross country team won A.A.U. title.

1940–Walsh Auditorium-Gymnasium opened.

1943–M.A. in administration and supervision, and guidance offered; New Jersey C.P.A. Board approved business and accounting curriculum.

1946–94% of enrolled students were veterans.

1948–WSOU/FM went on the air, the first collegiate operated radio station in the State of New Jersey.

1950–Seton Hall College became Seton Hall University.

1951–School of Law founded, with Miriam Rooney as the first woman dean of law in the United States.

1951–Swimming team won Eastern Collegiate Championship.

1952–Boland Hall opened.

1952–Andy Stanfield of the track team won first place for the United States at the Helsinki Olympics.

Continued on page 95.

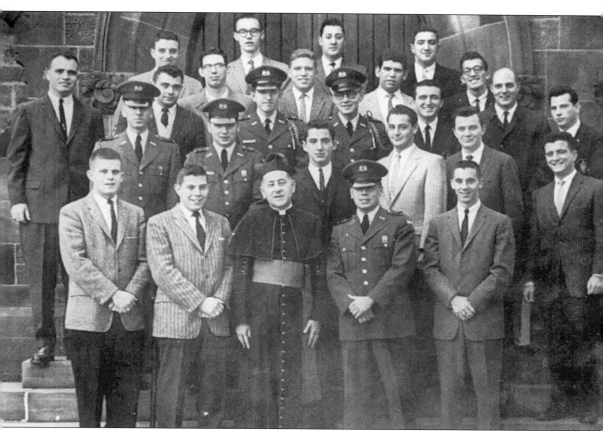

Msgr. Walter Jarvais poses in front of President's Hall with a wartime class between 1940 and 1945.

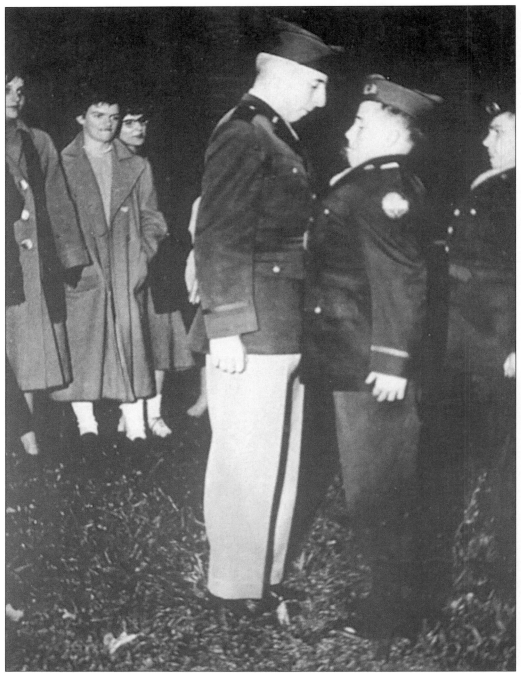

P.R. Master Sgt. James Giuliano "braces" pledge William Bevensee.

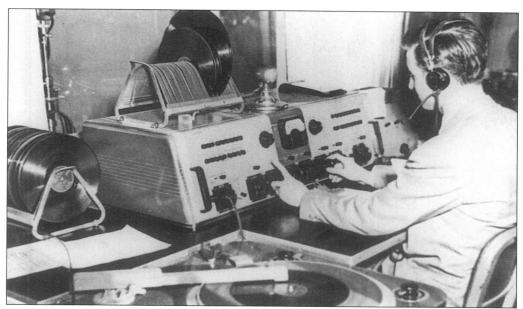

The Seton Hall radio station, WSOU, was founded in 1945.

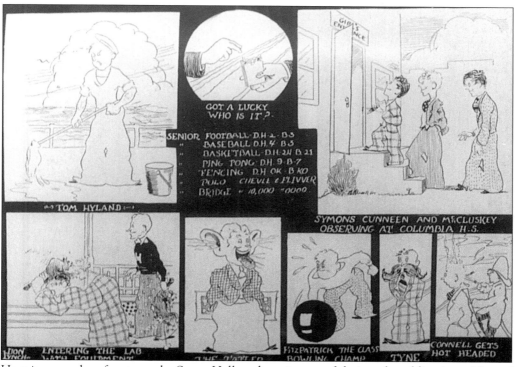

Here is a sampler of cartoons by Seton Hall students in one of their early publications. Most of the humor is geared to the personalities and antics of students.

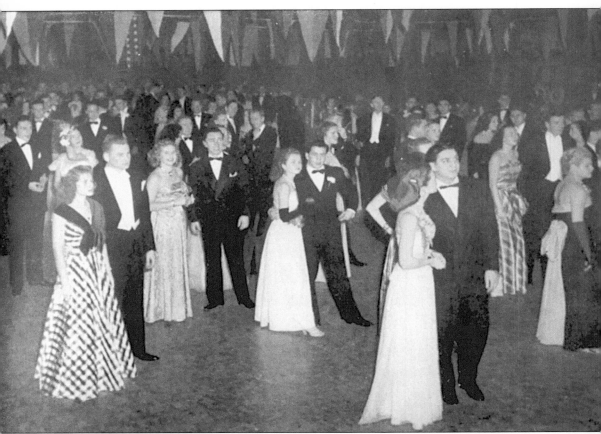

The Galleon Ball was always a formal and major social function.

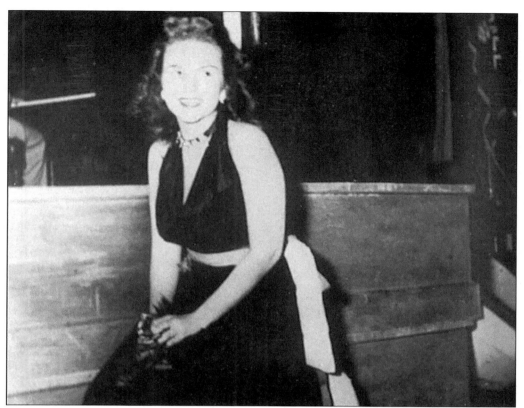

Miss Dolores Burnside, "Queen of the Good Ship Galleon," smiles for the camera in 1947.

This is the Bishop McLaughlin Library opened in 1955.

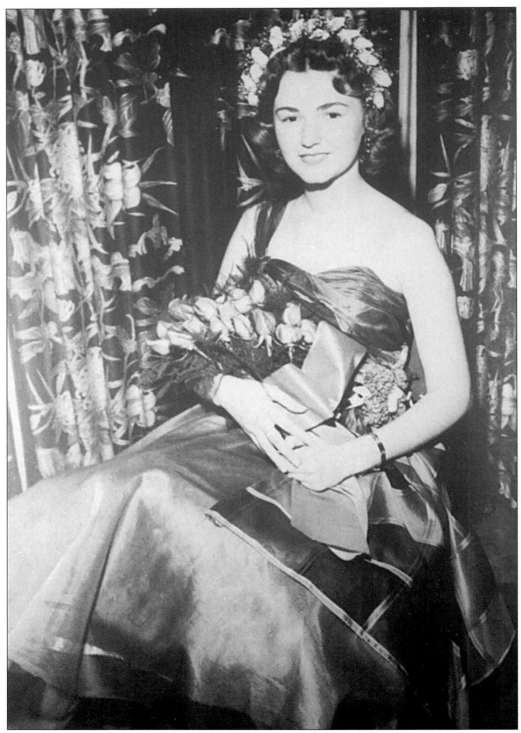

Jean Shilling, Queen of the 1954 Military Ball, cradles a bouquet.

Three
YEARBOOK STYLE
CANDIDS

Never too old (or late) to learn.

—ENGLISH PROVERB

'Tis education forms the common mind,
Just as the twig is bent, the tree's inclined.

—ALEXANDER POPE

For Seton Hall we render thanks to God;
Through years in which she glorified her name,
Sustained was she by His Almighty Hand;
In years to come, may blessing and may fame
That ever come from out the Hand of God,
Accrue to Seton Hall at His command.

—FROM "SETONIA, 1856–1931," BY GUY H. POPHAM JR., '32

This wonderful world, which God gave us so that we might learn about ourselves in it, is incredibly abundant.

—STUART WILDE, AFFIRMATIONS

Thou shalt love thy neighbor as thyself, one of the two great commandments, may also be interpreted as:
Do unto others as you would have them do unto you, also known as

—THE GOLDEN RULE

There is only one thing that can kill the Movies, and that is education.

—WILL ROGERS

All the photographs in this section are unidentified candids from the Special Collections of Seton Hall University archives. Here a young man kisses a baby in a group shot.

Students sprawled on the lawn, allegedly studying, on beautiful days. On warm days students traditionally head for the campus green. On today's beautifully landscaped campus, traffic is barred from the green, creating the quiet park-like surrounding of so many years ago.

A proud graduate poses in full regalia.

Three students spoof Hitler.

A dapper young Setonian poses with a serious face and sporting a blazer, white pants, and shoes.

A young man in uniform is pleased to be photographed with his adoring family.

A "racy" candid of young Setonians, including the girls, was taken at a social event.

A young fellow and a behatted, well-dressed woman with a fur collar sit on a sofa and smile for the photographer.

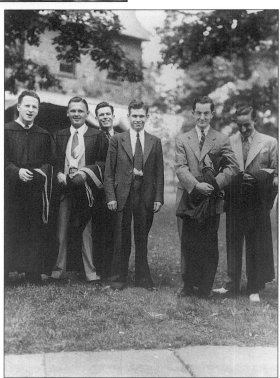

A group of young graduates holds their robes after the ceremony.

A graduate in his cap and gown brandishes his diploma. His boyish grin portrays his happiness to have made it through.

Three dapper Setonians lean against an elaborate mantel. Most picture-taking years ago meant posing to look one's best or to make a statement.

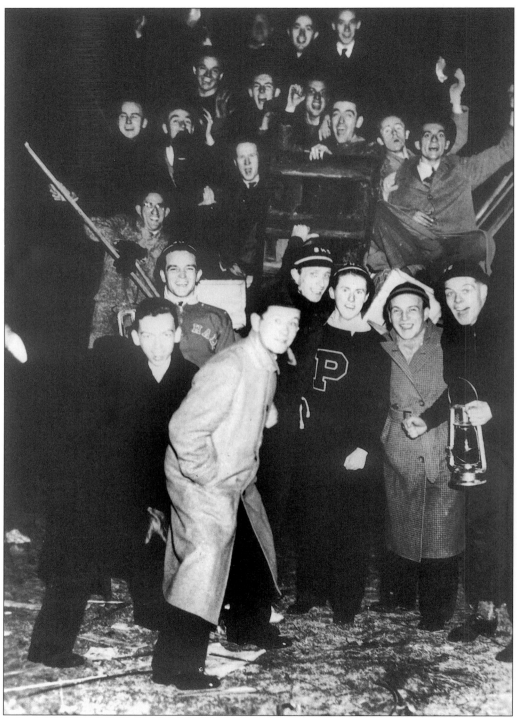

A lively rally gives students a chance to show their school spirit and make faces for the camera.

Four
TOUCHDOWNS, HOOPS, BATTERS-UP, ETC.

Whelan is our pitcher, he's swiftest ever seen;
And there's our champion catcher, McCarthy is his name.
Saint is on first base—he plays there tip-top,
And Hayes is on the second base, and Mullan, shortstop.

Shanley's on the third base, as you are all aware,
And Dowd is in the left field—the swiftest ball can't scare.
McCabe is in the center field and never muffs a ball;
O'Connor's in the right field, the surest of them all.
—POEM WRITTEN FOR THE LINE-UP OF THE SETON HALL
BASEBALL TEAM OF 1872, "THE ALERTS"

A baseball club from Jersey City came to play our College Club, which beat them famously.
—FROM BISHOP BAYLEY'S DIARY, JUNE 1865

Oh, where's the team can beat us
At football on the green,
Or say they can defeat us?—
Remains yet to be seen,—
We break right thro' their center
As tho' it were a hole,
And stop not till we enter
Behind the enemy's goal.
—FROM THE COLLEGE SONG

Seton Hall was known in the world of college sports; little is known of the record of these pioneer teams,
but they seem to have been at least moderately successful, as in that year Bishop McQuaid said that the
reason Seton Hall athletes 'won most of their contests was because of the excellent roast-beef, home-
made bread and farm-raised vegetables with which the table was abundantly supplied.'
—FROM THE SETONIAN, DIAMOND JUBILEE EDITION, JUNE 4, 1931

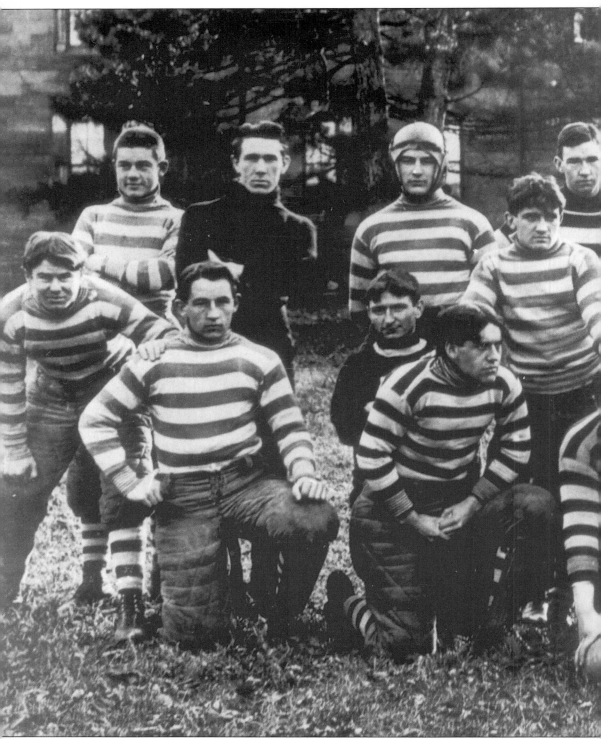

Football team, "The Alerts," of 1899, went all out to appear intimidating and tough, but most

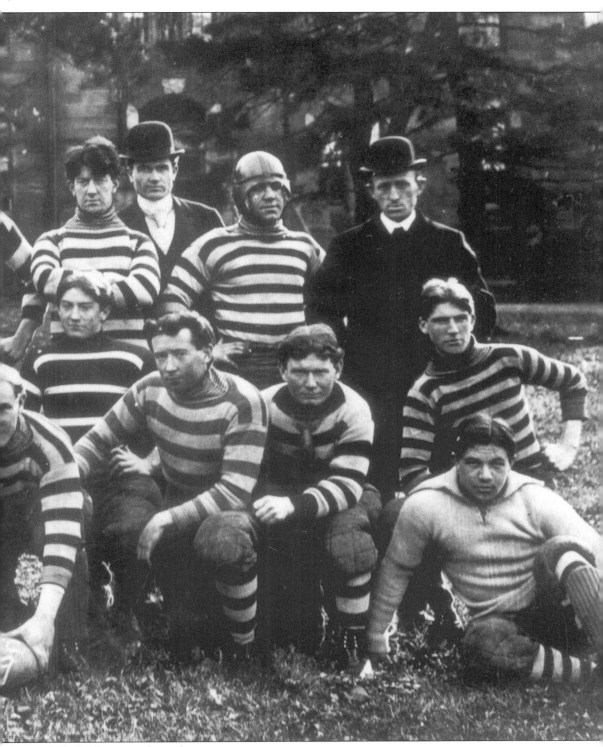

of all, dead serious about the sport.

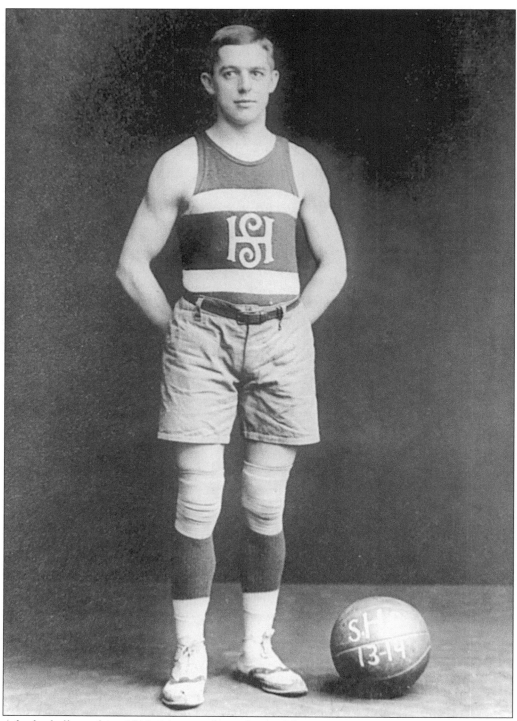

A basketball star from 1913–14 seems shy in front of the camera.

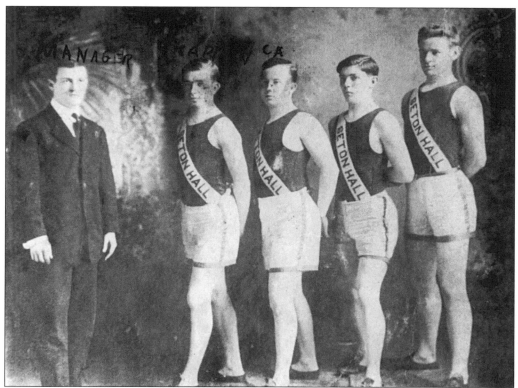

Four early track team members pose with their manager (left). The second and third from the left are the captain and his assistant, respectively.

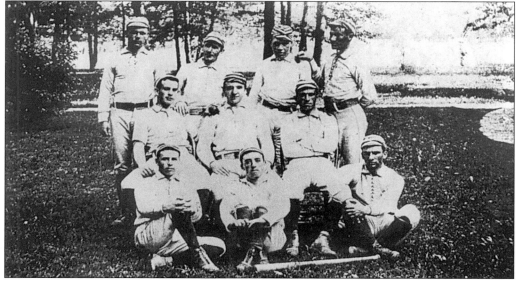

The Seton Hall baseball team of the early '90s was a source of great school spirit.

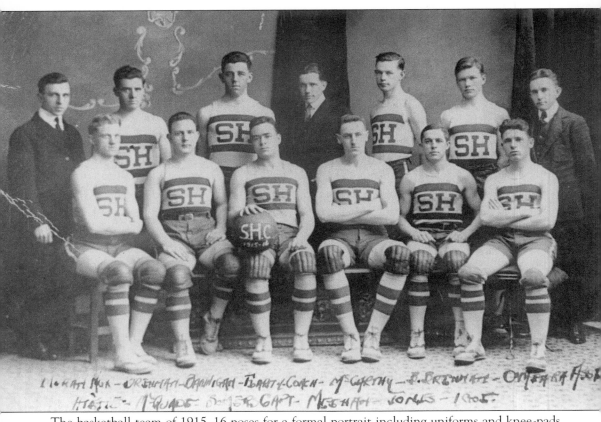

The basketball team of 1915–16 poses for a formal portrait including uniforms and knee-pads and an inscribed basketball.

The score of this 1906 baseball game at Seton Hall College is Manhattan 3, Seton Hall 11.

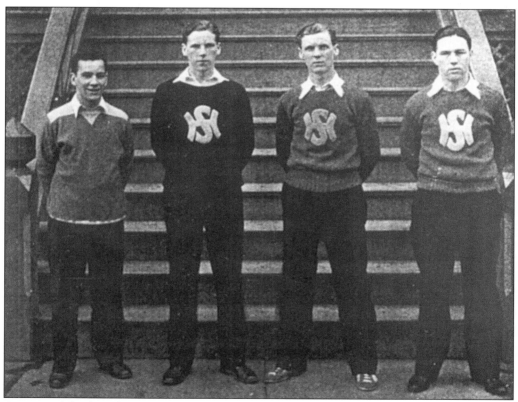

One out of the four cheerleaders is smiling.

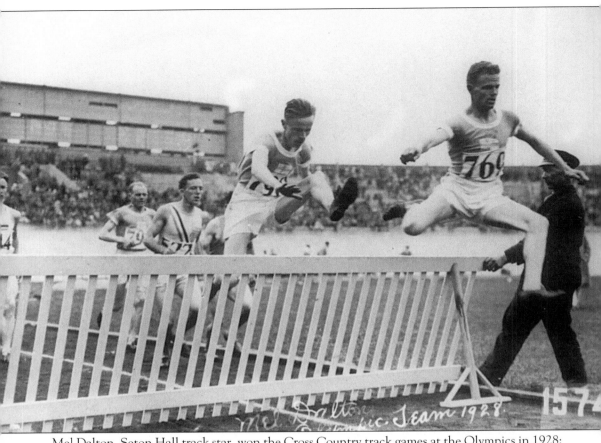

Mel Dalton, Seton Hall track star, won the Cross Country track games at the Olympics in 1928;
his medal is in the possession of the college archival collection. Dalton became a priest.

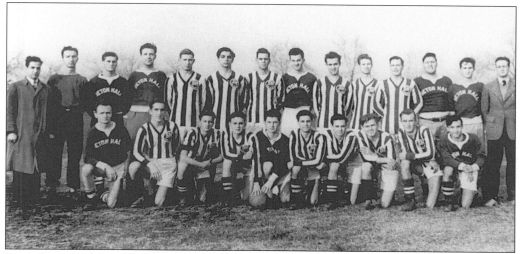

Sixth from the left is Nick Menza, a well-known coach of Seton Hall University soccer. Also pictured standing at the left is Coach George E. Miele, 1942.

Basketball players of 1939–40 pose, with Bob Davies at the far right.

The new Walsh Gymnasium pleases swimmers in 1939–40.

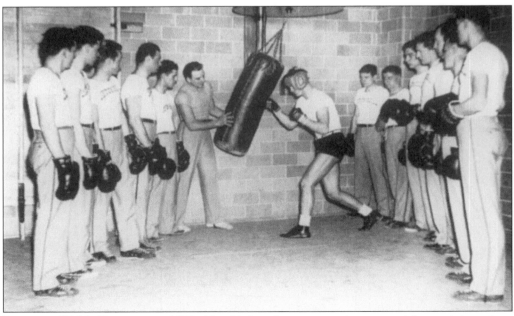

Boxing at Walsh Gymnasium, 1939–40, added to the sports options one might participate in.

Bob Davies enjoyed stardom under Coach John ("Honey") Russell.

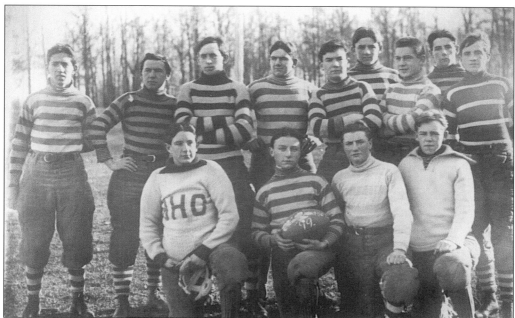

The 1899 football team kicked off the athletic prowess of SHU men. The first athletic director and coach of baseball and football teams was John Fish, in 1926.

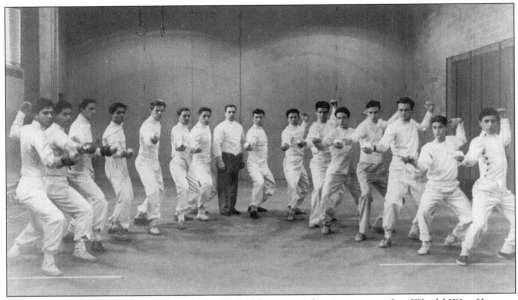

Vic DeFilippo (center) fenced with the U.S. Champion fencing team after World War II.

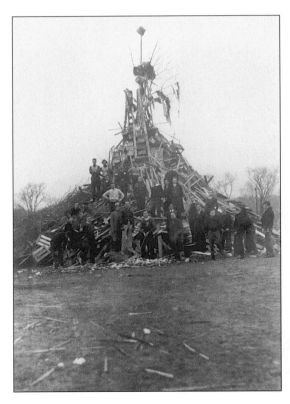

Flammables are piled high in 1939 for the bonfire that was held prior to the annual game between Seton Hall Prep and St. Benedict's.

Now it is *en flambe!*

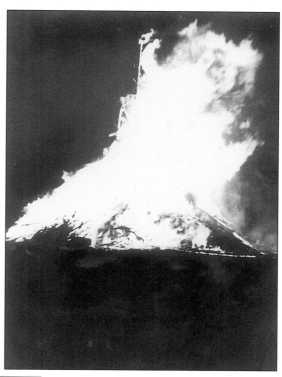

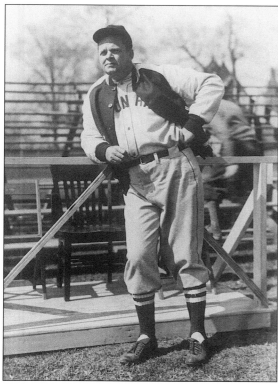

Al Mamaux was the coach of the
Newark Bears and the Seton Hall
University Yankee Farm baseball team.

At the left is Mike Shepherd, baseball coach, with an unidentified player.

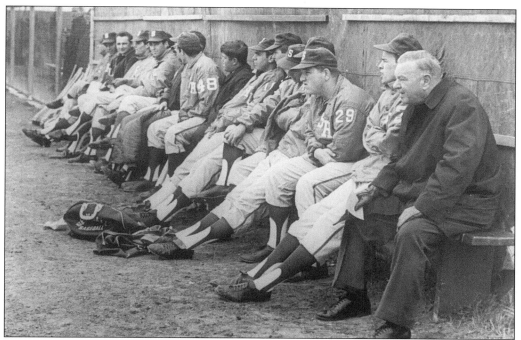

Coach Owen Carroll sits at the right with the baseball team.

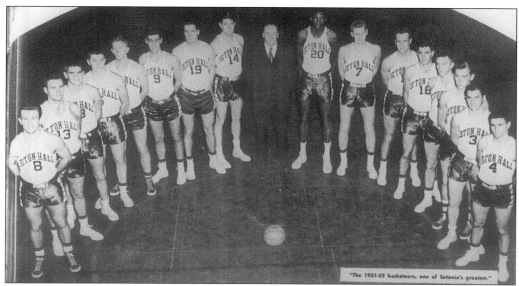

"The 1951-52 basketeers, one of Setonia's greatest."

In a semi-circle are the "the 1951–52 basketeers, one of Setonia's greatest."

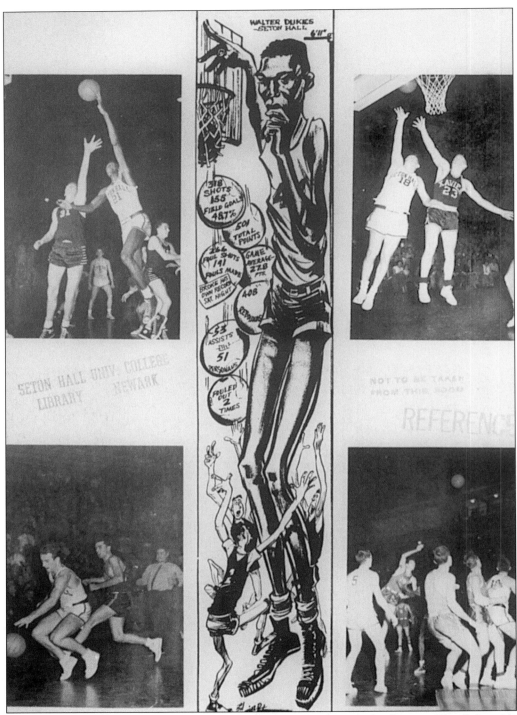

Walter Dukes's caricature anchors the four photographs on a yearbook page. The 6-foot-11-inch Dukes made 318 shots, 155 field goals, 501 total points, 266 foul shots, 141 fouls, 27.8 points game average, 408 rebounds, and 53 assists.

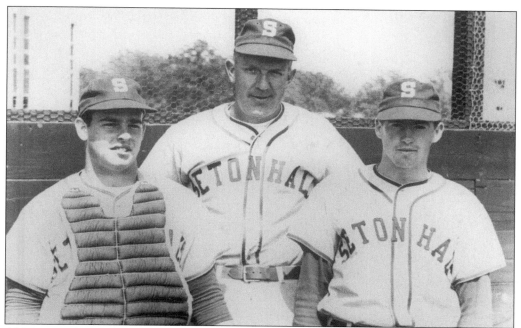

Al Mamaux (center) was known, according to Msgr. Field, to have eaten a whole loin of pork in one sitting.

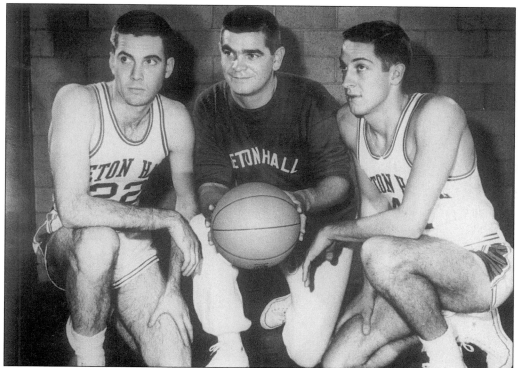

Head Coach Richie Regan (center) poses in 1960 with two players. Regan was the basketball coach for the next ten years.

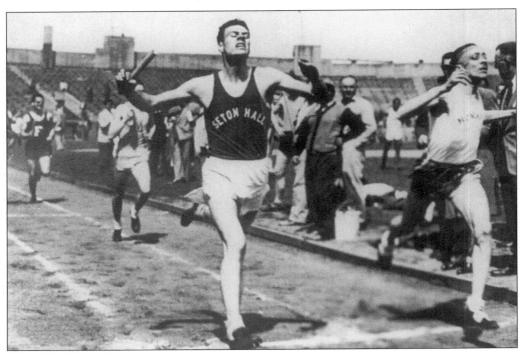

A track team member reaches the finish line.

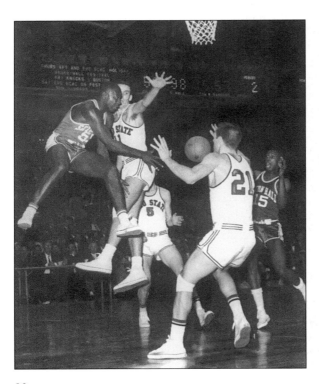

This game in progress shows airborne players.

A player makes a basket.

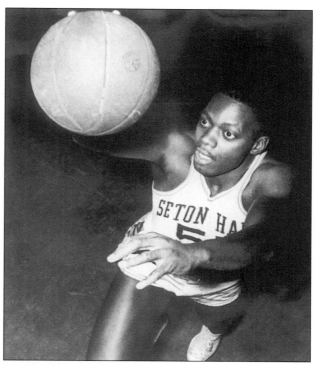

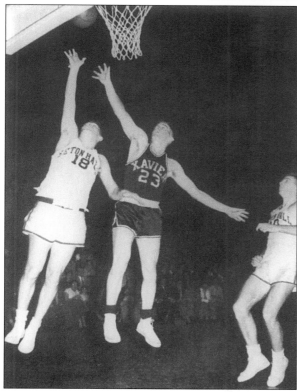

"Take Me Out to the (Basketball) Game" between Xavier and Seton Hall.

Manager Ellen O'Kane wears a big corsage at a game.

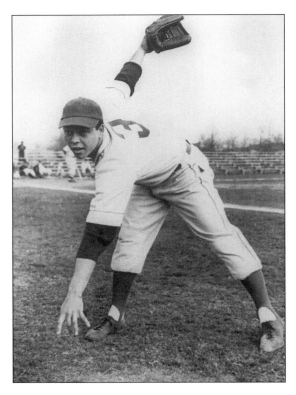

Here is a baseball player, *c.* 1971–81.

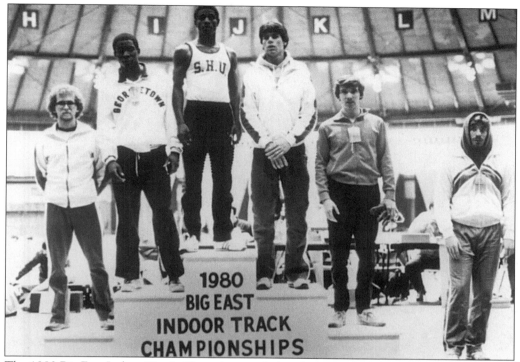

The 1980 Big East Indoor Track Champions include a Seton Hall student on the highest level.

1953–Basketball team wins 27 consecutive and the National Invitational Tournament; Walter Dukes and Richie Regan named to All-American team.
1954–McNulty Hall opened.
1954–Paterson College began as an extension branch of Seton Hall (operated until 1979).
1955–Institute of Judaeo-Christian Studies established.
1955–McLaughlin Library opened.
1956–College of Medicine and Dentistry started; taken over by the State of New Jersey in 1964.
1964–Baseball team participated in the College World Series in Omaha, Nebraska.
1964–First Ph.D. program offered in Chemistry.
1966–Upward Bound Program established.
1968–Humanities Building dedicated.
1968–South Orange campus became fully coeducational.
1968–Educational Opportunity Program established.
1970–Center for African-American Studies inaugurated.
1971–First Residence Hall for women opened on September 2.
1972–Pub opened in Student Center.
1973–Stillman Business School/Nursing College Complex dedicated on May 11.
1974–Puerto Rican Institute established.
1975–Track and field team won both the indoor and the outdoor IC4A championships.
1975–St. Elizabeth Ann Seton canonized in Rome.
1976–New Law Center in Newark dedicated on May 3, with U.S. Supreme Court Justice Thurgood Marshall as speaker.
1980–Doctoral program in the School of Education inaugurated.

Continued on page 125.

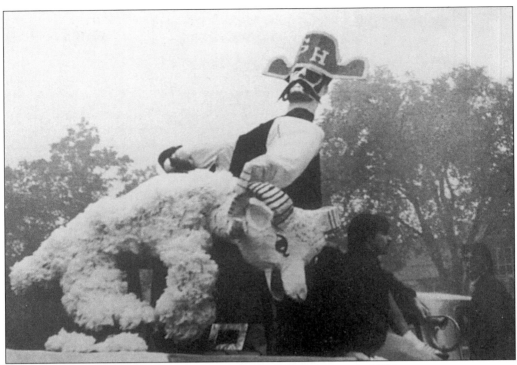

A float features the pirate theme for the Seton Hall Pirates team in 1974.

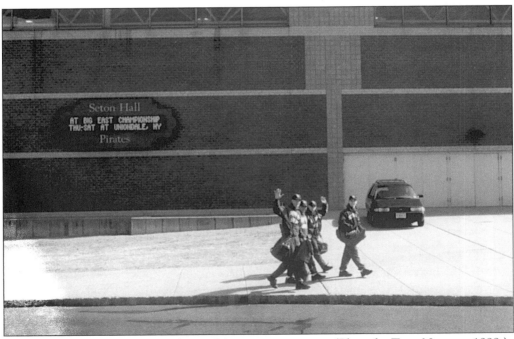

Members of the Pirates wave in front of the new gymnasium. (Photo by Tova Navarra, 1999.)

Five

"As It Was In the Beginning" Greatly Expanded

Seton Hall University's great boast and claim to fame is not predicated on expansion, buildings, or even curriculum. It lies rather in the minds and hearts of a dedicated and devoted faculty.
—FROM *THE CENTENNIAL STORY OF SETON HALL UNIVERSITY, 1856–1956*

*A tree that can fill the span
of a man's arms
grows from a downy tip;
A terrace nine storeys high
rises from hodfuls of earth;
A journey of a thousand miles
starts from beneath one's feet.*

—LAO-TZU

Prayer enlarges the heart We make mistakes. But He cannot make mistakes. He will draw the good out of you. That's the beautiful part of God, eh? That He can stoop down and make you feel that He depends on you To us what matters is an individual. If we wait till we get the numbers, then we will be lost in the numbers. Love is a fruit which is always in season. Let no one ever come to you without leaving better and happier.

—MOTHER TERESA

I think pain is a wretched gardener. Her cuts stun and sting. But after pruning, preferably voluntary, we're able to discern what's real, what's important, and what's essential for our happiness. Be of good cheer. Study your plants and study your lifestyle. When the right time arrives, go into the garden with sharp shears. Speak kindly. Pray softly. Prune back. Now plow ahead.
—SARAH BAN BREATHNACH, *SIMPLE ABUNDANCE*

The whole of life lies in the verb seeing.
—TEILHARD DE CHARDIN

Do not seek to follow in the footsteps of the men of old; seek what they sought.
—BASHO

Centuries of knowledge are compressed in revelatory moments.
—DEEPAK CHOPRA, *THE WAY OF THE WIZARD*

Paterson (at the c. 1954 opening) was the only Seton Hall school to receive a Woodrow Wilson scholarship. It was closed by Bishop Dougherty. He also closed the medical school.

Russell Rauch, class of 1954, sports the freshman beanie, which, he said, was sort of an embarrassing part of campus life then, and a funny anecdote today. Rauch was in the campus ROTC and worked at WSOU radio station. He went on to become a journalist.

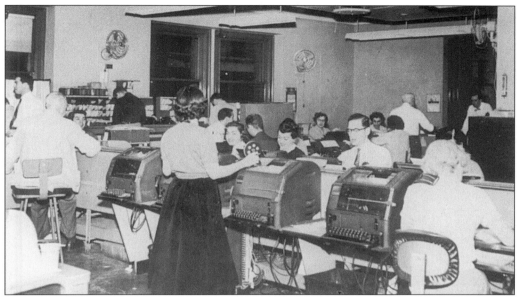

"The Cutting Edge of Technology" is a photograph of the Business/Management program of 1956.

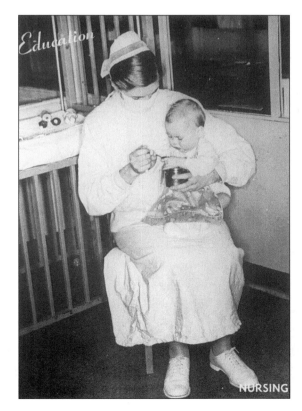

In the 1957 *Galleon* yearbook, a Seton Hall nursing student is shown tending a baby. The first nursing courses were offered in 1940.

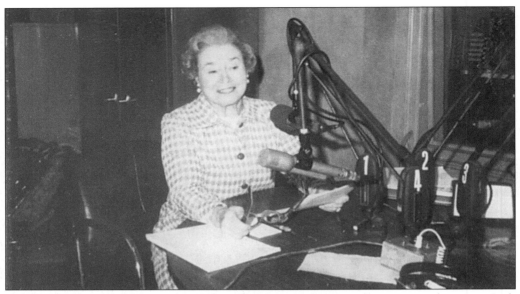

Rita Murphy, '38, majored in English and history and received a master's degree in Irish literature and history. On St. Patrick's Day 1958, Rita was asked to do a WSOU radio show that was such a hit that it became a weekly, half-hour program called "Pageant of Ireland." One who delighted in discussing Irish music, literature, history, and the Irish in America on and off the air, Murphy served as director of the Institute of Irish Culture at Seton Hall.

WESTERN UNION
TELEGRAM

1207 (4-55)

W. P. MARSHALL, PRESIDENT

Dear Right Reverend Monsignor John L. McNulty:

To you and all officers, faculty members, students and alumni of Seton Hall University, I extend warm greetings, and congratulations on its 100th anniversary.

As the University enters its second century, all of you have my best wishes for inspired service to the advancement of learning and to the development of responsible citizens.

Sincerely yours,

Dwight D. Eisenhower
President of the U.S.A.

A Western-Union telegram from President Dwight D. Eisenhower to Rev. John L. McNulty congratulates Seton Hall's 100th anniversary in 1956.

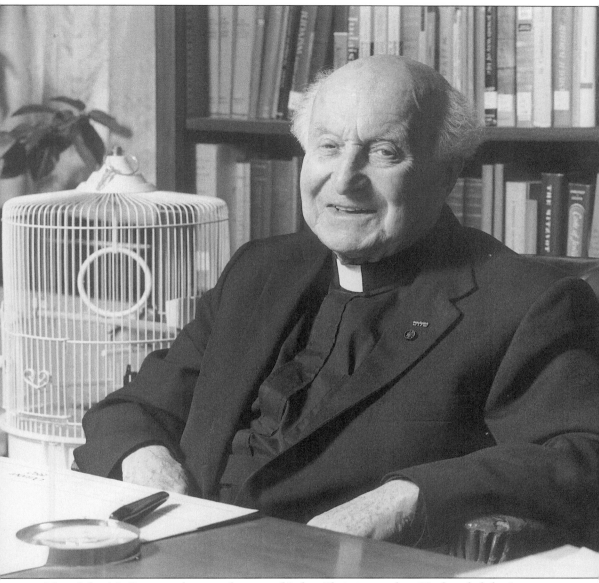

Msgr. John M. Oesterreicher was director of Judeo-Christian studies. He founded the Institute of Judeo-Christian studies on campus in 1955. Born in Moravia in 1904, Msgr. Oesterreicher began life as a Jew, but was ordained in Austria. He was one of the authors of *Nostra Aetate 4*, the Statement in the Church and the Jews. He had an illustrious career and is especially remembered for his leadership in the effort to rediscover Judeo-Christian kinship.

The young Very Rev. Msgr. William Noe Field, M.L.S., is pictured in the yearbook of 1954.

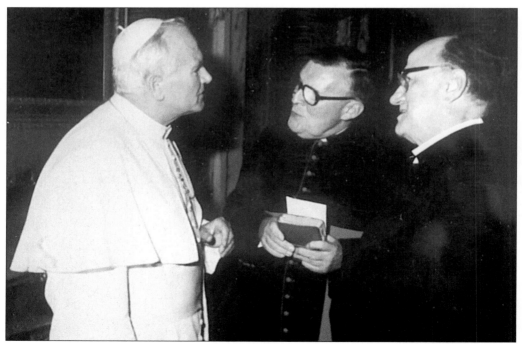

In 1980, Msgr. Field greets Pope John Paul II. To the right is Msgr. Eugene Fanelli.

Rev. Edward Fleming, Ph.D., was Dean of the University College. He later held many other positions including acting president of the college.

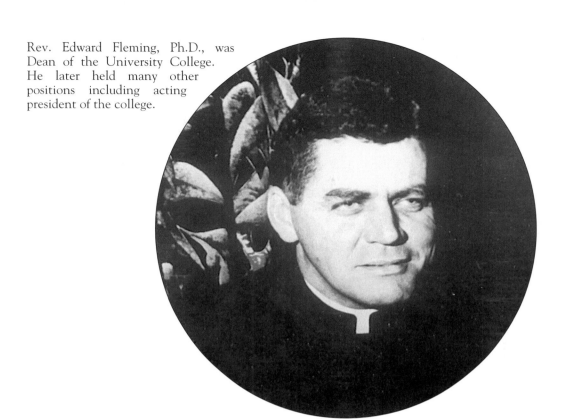

These are two business school men look over "the books."

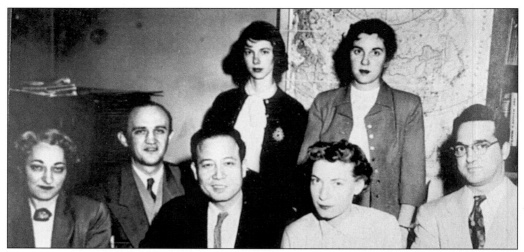

Pictured are students from the Institute of Far Eastern Studies. Seated are, from left to right, Celest Invento, Richard V. Chesner, Dr. Dan, Frances Heaney, and Robert Clarizio. Standing are Marilyn Bryan and Phyllis Howell. The well-developed Department of Asian Studies of today is housed in Fahy Hall.

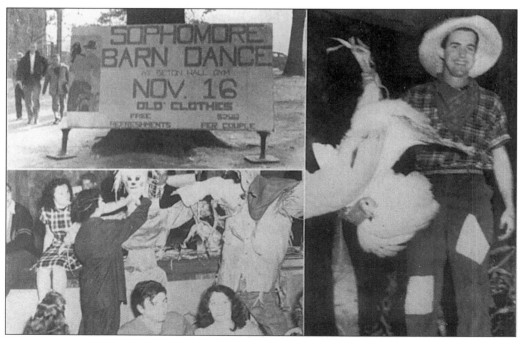

The Sophomore Barn Dance held at the Seton Hall Gym charged $2 admission per couple.

Rev. Thomas G. Fahy, 14th president, presided over a university of some 12,000 students and faculty.

Msgr. Fahy said, "My greatest satisfaction this year has been the improvement of our financial position. We've been able to succeed on our own, and the prospect of future stability is bright. If state aid is approved, we could add a new $600,000 scholarship fund to our resources. I'd love to see that happen." His other goals included peace, especially after the 1960s student demonstrations, on campus. He proclaimed that all students—dorm residents, commuters, Paterson campus students, black students, and white students—have to live together and work for peace. "After all," he said, "the University is not meant to function out of a crisis situation. Our obligation is to prevent them."

MSGR. THOMAS G. FAHY
14th president of
seton hall university

Over a year has gone by since the speeches, the promises, the pomp and ceremony of inauguration. And Msgr. Thomas Fahy has adapted to the task of Seton Hall's 14th president. Presiding over a University of some 12,000 students and faculty, serving as chairman of the University Senate and treasurer of the Board of Trustees, he still manages to find the time for teaching. But most of all he still finds time for people—maintaining a rapport between campus factions that is more often like a delicate balance.

Meeting with people—his "favorite part of the job"—takes up a good deal of his time. Every Tuesday, for most of the day, his office is open to any member of the University community with questions, complaints or demands. And for the rest of the week he can generally be found in his office or across campus, "listening and learning" with administrators, faculty or students.

"My greatest satisfaction this year," he reflects, "has been the improvement of our financial position. We've been able to succeed on our own, and the prospect of future stability is bright. If state aid is approved, we could add a new $600,000 scholarship fund to our resources. I'd love to see that happen."

Peace is another of the Monsignor's primary goals. After a year of relative tranquillity, the campus peace was jarred last semester by a few minor crises and one major confrontation that prompted the establishment of a special president's committee on campus polarization.

Msgr. Fahy still sees a simple solution: "It's the students. The dorm residents, the commuters, Paterson, the black and white students—they've all got to live together. We've got to work for peace. It's something to which everyone must contribute."

"After all," he reasons, "the University is not meant to function out of a crisis situation. Our obligation is to prevent them."

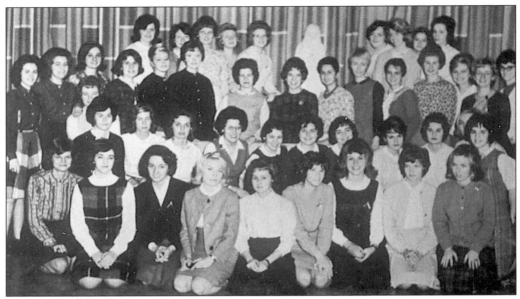

The New Jersey Student Nurses Association is pictured here.

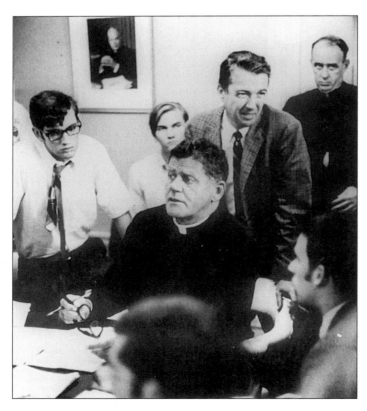

Pictured at left are Msgr. Edward Jude Fleming (center), Gene Collins, publicist, and Father James McMenamie (top right), president of the Tribunal.

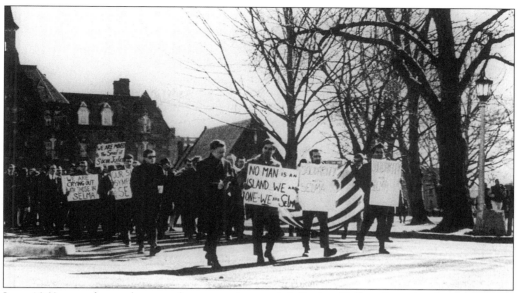

In a 1960s parade, students took over and occupied Bayley Hall and set bonfires on South Orange Avenue. "We are crying out with those in Selma," reads one sign. Others read, "No man is an island. We are One. We are Selma," and "Solidarity with Selma."

Officers of the University 1997–98

Reverend Monsignor Robert T. Sheeran, S.T.D.—President
Mary Meehan—Vice President and Assistant to the President
Catherine R. Kiernan, J.D.—Vice President and General Counsel
Peter G. Ahr, Ph.D.—Interim Provost
Kimberly R. Cline Ed.D., J.D.—Vice President for Finance & Administration
John H. Shannon, J.D.—Vice President for University Affairs
Laura Wankel, Ed.D.—Vice President for Student Affairs
Reverend Monsignor William C. Harms, D. Min.—Vice President for Planning
Dennis Garbini, M.B.A.—Vice President for Technology

Academic Officers 1997–98

James VanOosting, Ph.D.—Dean, College of Arts and Sciences
Sheldon Epstein, Ph.D.—Interim Dean, School of Business
Sylvester Kohut Jr., Ph.D.—Dean, College of Education and Human Services
Barbara A. Beeker, Ed.D.—Dean, College of Nursing
Terence L. Blackburn, J.D.—Acting Dean, School of Diplomacy and International
 Relations
Reverend John W. Flesey, S.T.D.—Rector/Dean, Immaculate Conception Seminary
 & School of Theology
John Paterson, D.D.S.—Dean, School of Graduate Medical Education
Ronald J. Riccio, J.D.—Dean, School of Law
Arthur W. Hafner, Ph.D.—Dean, University Libraries

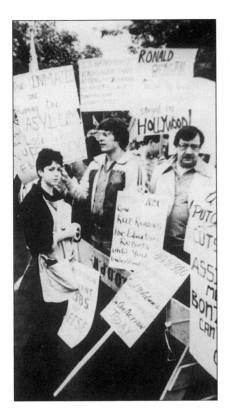

Shown is another campus demonstration in the 1980s. Some of the signs say: "The inmates are running the asylum" and "Ronald Reagan should have stayed in Hollywood."

In the top photograph, a student dressed as Paul Revere rides a horse bearing the sign: "Paul Revere II rides for a peaceful, non-nuclear world." The campus welcomed a group known as the Caravan for Human Survival, which made its last stop there after a series of visits to universities around the country. Rev. Robert Antczak represented the faculty, and Marc Bouvier represented the student body.

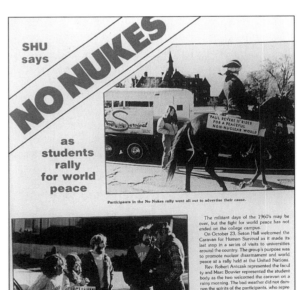

SHU says NO NUKES as students rally for world peace

Participants in the No Nukes rally went all out to advertise their cause.

Waiting for the caravan to arrive are (l-r) Mauri Mission, Linda Franke, John McMahon, Marc Bouvier and Rev. Robert Antczak.

The militant days of the 1960's may be over, but the fight for world peace has not ended on the college campus.

On October 23, Seton Hall welcomed the Caravan for Human Survival as it made its last stop in a series of visits to universities around the country. The group's purpose was to promote nuclear disarmament and world peace at a rally held at the United Nations.

Rev. Robert Antczak represented the faculty and Marc Bouvier represented the student body as the two welcomed the caravan on a rainy morning. The bad weather did not dampen the spirits of the participants, who represented 40 colleges from as far west as Minnesota and as far south as Miami.

Among the schools that participated were the University of South Carolina, the University of Pennsylvania, Fairleigh Dickinson, the University of Connecticut and Boston University.

Special ceremonies were planned for the caravan's visit to the campus, beginning with the lighting of a torch to represent friendship. Members of the university were asked to sign the Human Manifesto, written by Norman Cousins, who is an author, editor and president of the World Federalists Association. This list of signatures was presented to the caravan that morning.

23

WSOU never expected media attention world-wide when they decided to . . .

BAN BILLY JOEL

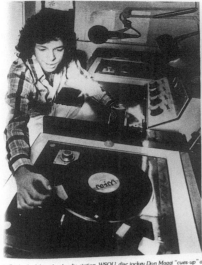

In Studio A of the school radio station, WSOU, disc jockey Don Maggi "cues-up" a record.

To places as far as Tokyo, Japan, the news had spread. Seton Hall's student-run radio station, WSOU, made headlines in newspapers around the world. The reason was not their fine programming or an innovative technique but rather the controversial decision to ban a widely-known song by singer/songwriter Billy Joel. "Only the Good Die Young," seen as a mockery of Catholic conservatism and therefore inconsistent with station policy, was not allowed on the air, as decided by Director of Radio and Communication professor, Kevin Hislop, and the Board of Directors of WSOU.

Station Manager John Tomasicchio, Program Director Barry Smith, News Director John Cerone, and Director of Operation Peggy Harris comprise the station board and were responsible in maintaining WSOU as one of the oldest and best student-run radio stations in the country.

Making the controversial move to ban not only Billy Joel's song but also a group of other "offensive and potentially harmful" songs, the board felt they were upholding the values and standards of the campus community. The decision stirred considerably mixed feelings on

Billed as one of the oldest and best student-run radio stations, WSOU launched a ban on the music of Billy Joel, especially his song "Only the Good Die Young," in which lyrics were interpreted as a mockery of Catholic conservatism. This went against station policy set by the station board of directors. Station officials included director of radio and communication professor Kevin Hislop, station manager John Tomasicchio, program director Barry Smith, news director John Cerone, and director of operation Peggy Harris.

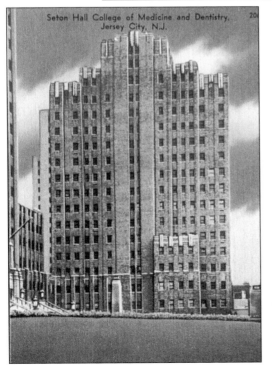

The former Seton Hall College of Medicine and Dentistry in Jersey City, New Jersey, is pictured above. (Collection of Cynthia Harris.)

The 1973 Galleon yearbook depicts a young Setonian playing Frisbee.

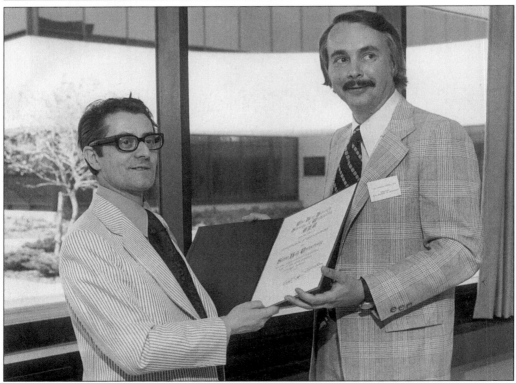

Former head of the art and music department Dr. Louis de Crenascol (left) stands with Donald Gatarz, AIA, president of the New Jersey Society of Architects, received an award on May 11, 1974. (Van Picture Service, Newark.)

Pictured from left to right are Archbishop Peter L. Gerefy, an unidentified man, and Father Edward Ciuba, pastor at North Caldwell, *c.* late 1970s.

President Ronald Reagan congratulates actress/singer Pearl Bailey at the graduation ceremony at which she received an honorary doctorate. Behind Reagan (left in photo) is Edward D'Alessio, president of the university.

The late Pearl Bailey attends the commencement and speaks with strong enthusiasm on the power of education. This was the last graduation held on campus. The event became so large that it was since held at the Meadowlands arena.

Presidential hopeful Sen. George McGovern speaks at Seton Hall in 1974.

Dr. Edward D'Alessio, Seton Hall's
17th president is pictured here.

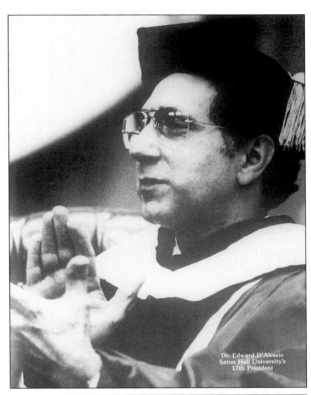

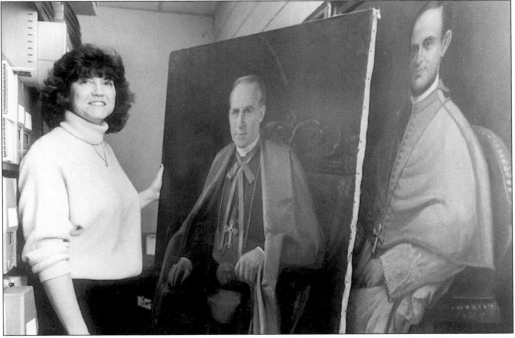

JoAnn Cotz, associate director of Special Collections, Walsh Library, stands with portraits of
Archbishop Thomas J. Walsh and Bishop Winand D. Wigger.

This campus tug-of-war shot was captured *c.* 1970s.

People are seen chatting after the seminary's traveling exhibit was shown at Seton Hall.

Six

EXODUS

(BUT YOU CAN ALWAYS COME HOME AGAIN)

From out the flames and billowed smoke
Fair Seton rises, and her heavenly cloak
Unseared preserves her from the brand
That angry winds to holocaust have fanned.

When 'merged she from the desolate ruin,
An angel comes to bear her boon
Of Upper Heavens, saying then,
"All hail, for thou shalt rise again . . .

And time shall touch thee not at all,
Nor Tragedy thee e'er befall;
But thou shall 'grave with golden pen
Thy mission on the souls of men.' —"EX IGNIBUS," BY CHARLES D. SAUER, '31

In the life of every institution there comes a time when it can pause and proudly look back on its accomplishments and from the achievements of the past, one may indeed receive inspiration for her glorious and blessed future.

—REV. JOHN L. MCNULTY, 12TH PRESIDENT, 1951

God is not mocked: for whatsoever a man soweth, that shall he also reap. —GALATIANS 6:7

Nothing would be done at all, if a man waited until he could do it so well that no one would find fault with it. It is enough, more than enough for me, if I do so much as merely begin what others may more hopefully continue.

—JOHN HENRY CARDINAL NEWMAN

Go where glory waits thee,
But, while fame elates thee,
Oh! still remember me. —THOMAS MOORE, 1779–1852, FROM "IRISH MELODIES"

Art professors Tony Triano (left) and Edwin Havas are pictured at left. The late Anthony Triano, born in 1928 in New Jersey, "produced (art) in series . . . to do full justice to his vast and universal themes," wrote Dr. Chu in "A Being Beyond," for a 1997 exhibition of Triano's paintings, sculptures, and drawings at Seton Hall.

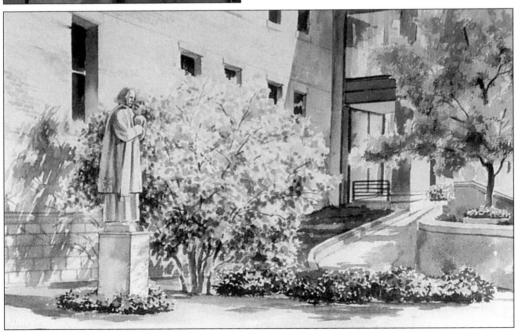

Professor Emeritus Edwin Havas produced this watercolor of Lewis Hall, the Immaculate Conception Seminary, as well as watercolors of the various sites on campus for the school's 1995 calendar. He is a member of the American Watercolor Society, and his work has won distinguished awards over his long career, which continues even beyond retirement.

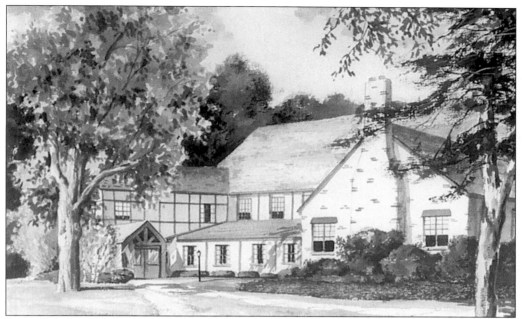

A Havas watercolor of St. Andrew's Hall (calendar) shows the expert command of a difficult medium. Havas taught at Seton Hall University and Seton Hall Prep School for 36 years. He won the McQuaid Medal for distinguished service in May 1996.

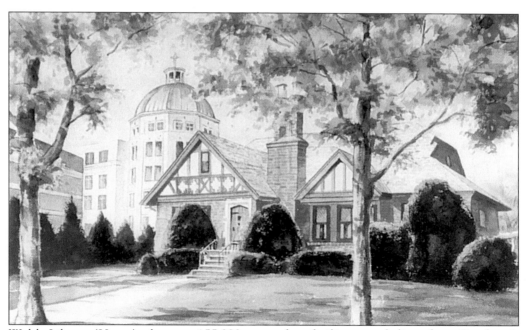

Walsh Library (Havas), the new 155,000-square-foot facility, was dedicated on October 1, 1994. It features all library facilities, an art and exhibit gallery and state-of-the-art technological referencing equipment. The dome of the library stands regally behind the university chancellor's home.

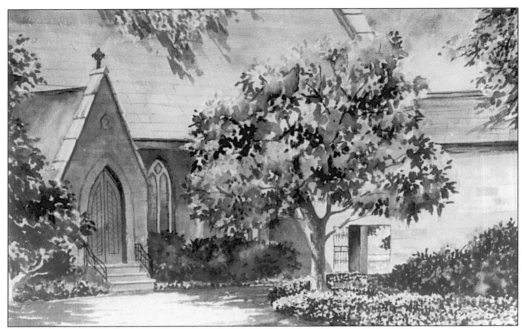

The Chapel of the Immaculate Conception by Havas provides a haven for meditation and reflection, and it has been the center of religious life on campus since 1863.

Bayley Hall, so finely rendered by Havas, the artist, was named for Bishop Bayley and today houses the offices of admissions, financial aid, career services, the registrar, the bursar, and academic services.

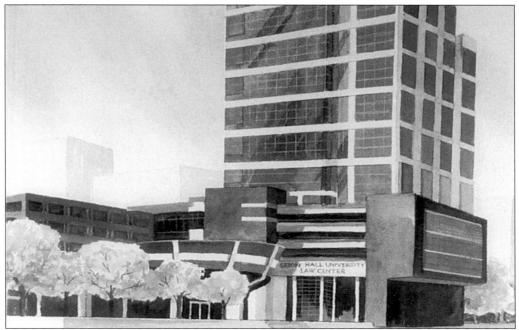

Seton Hall University Law Center in Newark, by Havas, AWS, was built in 1991.

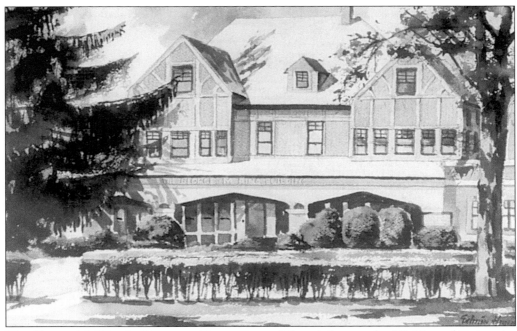

The George M. Ring building, on Center Street (Havas), houses the Division of University Affairs.

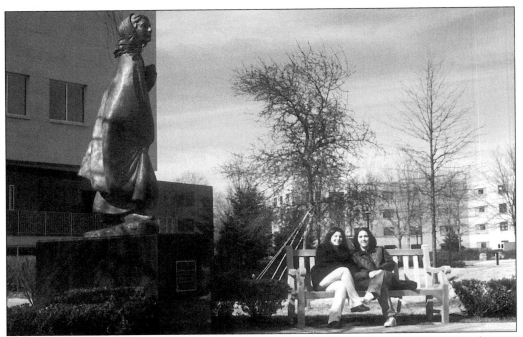

Two co-eds sit on a bench near the statue of Mother Seton, donated by Rev. Kevin Hanbury in memory of his parents. At the left is Megan Severins, class of '99, and next to her is Christine Shamin. Both women are special education majors.

A view of Cabrini Hall is a geometric study on a sunny afternoon.

Art and Music Department Chairman Dr. Petra Chu poses in her office in the Art Center. Under her direction, the department has evolved to a master's program in museum studies, a new graphics design program, full-time vocal, strings, and piano faculty members, art education courses, and other cultural openings, in addition to the undergraduate art and music curriculum.

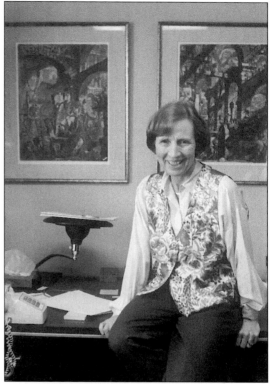

Professor Barbara Cate, of the art department, could usually be seen conducting her classes with a microphone, because she is soft-spoken, especially in a lecture hall.

Walking toward the Student Center is one of the most frequent travels of the SHU students.

This statue of St. Patrick is in front of Duffy Hall.

Msgr. Robert Sheeran is the current president of the university.

Duffy Hall is a modern-style building that today is in part the university bookstore.

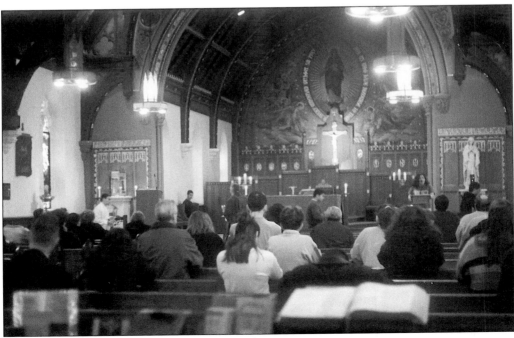

A Mass at the Immaculate Conception Chapel is in progress.

1980–Governance of Seton Hall restructured, with a 25-member Board of Regents and a 13-member Board of Trustees.

1980–Richard J. Hughes Chair for Constitutional and Public Law and Service dedicated at the Law Center, with Gov. Brendan Byrne and former Gov. Hughes in attendance.

1981–Educational affiliation agreement with the People' Republic of China promulgated.

1983–President Ronald Reagan receives an honorary degree and addresses graduates at Commencement.

1984–Immaculate Conception Seminary returns to South Orange from Darlington.

1985–Seton Hall Preparatory School moves to West Orange.

1986–A new residence hall opened on campus, Xavier Hall.

1987–School of Graduate Medical Education established.

1987–Seton Hall Preparatory School incorporates separately from the University.

1987–Robert E. Brennan Recreation Center opened.

1987–John M. Oesterreicher Endowment, Institute of Judaeo-Christian Studies.

1987–Keating-Crawford Chair of Business Administration, Dr. William A. Stoever, Chairholder.

1987–Rev. Stanley Jaki received the Templeton Award.

1988–Cabrini, Serra, and Neumann Halls, student residences, opened on campus.

1989–Gerety Hall, priests' residence, opened on campus.

1989–First stage of Capital Campaign started.

1990–Public announcement of five-year-long, $100,000 Capital Campaign

1991–Parking Garage opened on South Orange campus.

1991–New Law School building opened in Newark.

1992–Groundbreaking for Walsh Library.

1993–25th anniversary of the Educational Opportunity Program.

1994–Walsh Library opened.

1995–Demolish of McLaughlin Library and Groundbreaking for New Academic Support Building.

1996–Title of Chancellor/President separated into two positions.

1997–Kozlowski Hall opened—a six-story structure with more that 126,000 square feet of academic space.

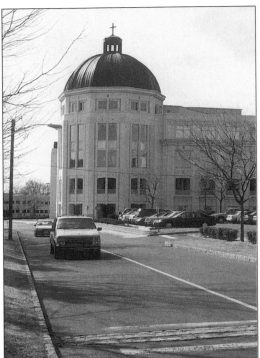

Walsh Library is known as the "Jewel of the Campus."

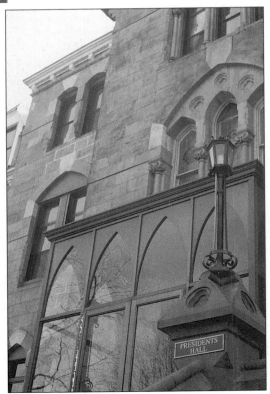

The contemporary addition to President's Hall has a glass-enclosed entrance.

Msgr. William Noe Field, university archivist, holds some of his memorabilia in his office.

Author's Note

Several years ago, I spotted a St. Elizabeth Ann Seton medal on a table at the Collingwood Flea Market and bought it for a dollar. Perhaps it was a foreshadowing of my doing this book: I was proud to be a Seton Hall graduate but had not yet made "direct contact" with Mother Seton. The medal called out to me in some mysterious way even though the only thing I knew about Mother Seton at that time was that she was the first American saint. Not one to traffic with intuition, I wore the medal for weeks, then put it away. Every once in a while I'd come across it while looking for something else, and it always held my eye for a good minute or two. I supposed it was just attractive and sentimental because I went to Seton Hall and thereafter taught art and music at Seton Hall Prep for three years.

Little did I suspect what was in store for me. I'd been writing regional history books for Arcadia Publishers when they decided to establish a series on American colleges and universities. Arcadia pitched the idea to its authors by way of a brochure. I remember staring at it, thinking certainly—no, most definitely—someone had already whisked away a contract for Seton Hall. Anyway, even if the contract was still available, why on Earth would it come to me and not someone far more astute and involved with the university than I? Still I was somehow "prodded." I called Arcadia and told one of the editors I would be eager to do a book on Seton Hall. It seemed only three minutes later that I signed the contract. I was ecstatic. My enthusiasm increased when I received the university's blessing and support for the project. A few days later, reality jabbed me in the side: Dear God, whatever made me think I could do this? I must be out of my mind. Terror replaced the ecstasy until I gathered photographs from the archives and other sources and read various historical accounts of the university. Once I typed in the title pages, front, and back matter of the manuscript, which I call "creating the block" (an inversion of Michelangelo's self-described process of removing every part of the stone that is *not* the sculpture), I felt better. Ecstasy would elude me until the entire manuscript went off to the publisher.

Other terrors surrounded me as well. Will the university support this project? Will it be well-received? Self-doubt plagued me to the point at which I thought: I can't do it. I just can't. Inspiration wasn't coming. Procrastination (which I usually break through quickly enough) rose to a pathological level. I would look at the pile of books, pictures, and papers—the ominous "Seton Hall file"—and scurry off to feed my dog, Francis Xavier, or do the dishes. I prayed for help, for a guiding phrase or two, for "new eyes" on the photos, anything that would catalyze.

So it came to pass that divine intervention would rescue me and somehow—perhaps with angels working my hands as though I were a marionette—get the show on the road. Reminiscences of my own years at Seton Hall welled up. I felt grateful for the enduring image of Dr. Julius Zsako as he responded passionately to music. I remember my piano instructor, Dr. F. Ming Chang, who made me play that damned Alban Berg "Sonata" at a formal recital. I had to laugh when I recalled Dr. Thomas Duff's English course. He requested that we each write a Shakespearean sonnet. One young man asked, "How long should it be?" Duff's deadpan reply was, "Oh, about 14 lines." I also remembered having received a C (horrors!) for an art history essay test given by Dr. Petra Chu, now chair of the art and music department. I marched up to her after class and asked why such a poor grade, when I believed I had answered the question correctly. Dr. Chu said, "Well, your answer was just so *brief*." Today, as an author for Arcadia, a publisher that demands brevity despite that there is so much information to impart, I wondered if I'd been practicing for my unexpected career in journalism. In December 1974, I received a B.A. magna cum laude. The honors shocked and delighted me. The professors of Seton Hall University had let me fly! Anyone who allows you freedom to be an *enfant terrible*, albeit one with a desire to live a creative life, deserves a lot of credit. I believe my undergraduate tenure at Seton Hall will continue to teach me to read, garner the lessons of many cultures, see artistically, and, with great hope, become a better person, a finer soul. Who could ask for more?
—Tova Navarra, Rumson, New Jersey, May 1999